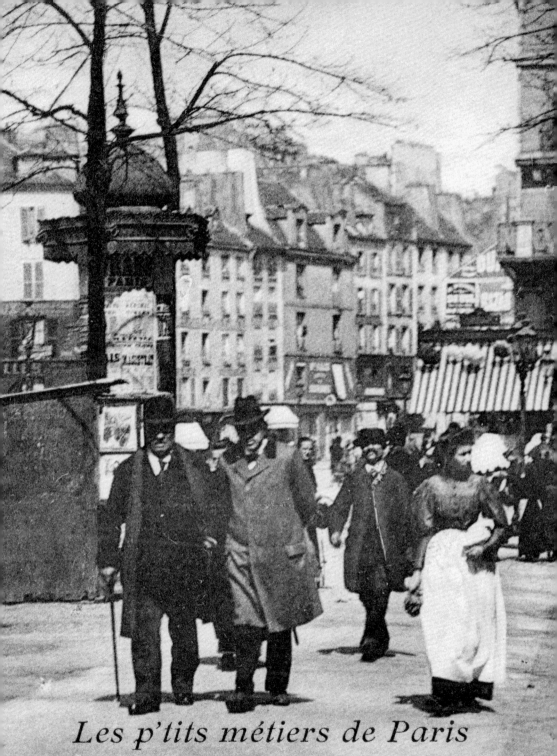

Les p'tits métiers de Paris

Vendeuses au panier — Ail, thym, laurier

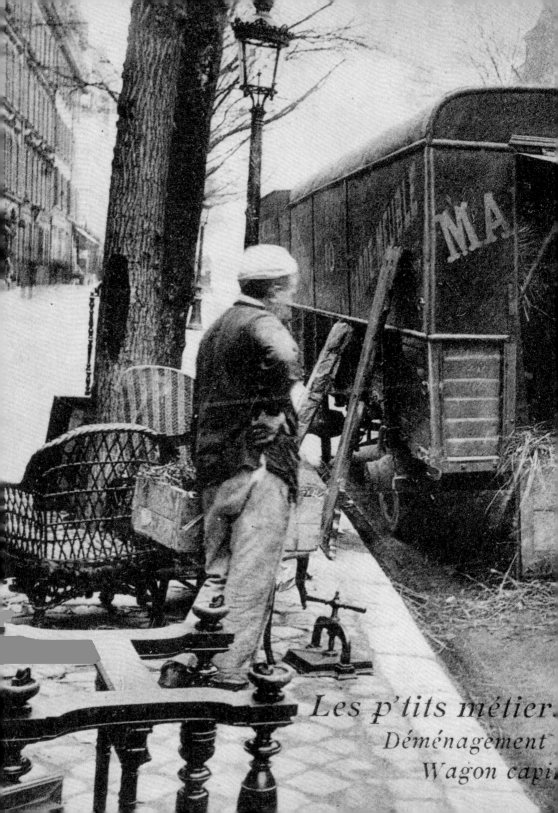

Les p'tits métier
Déménagement
Wagon capi

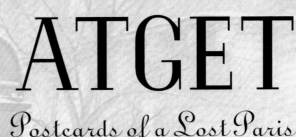

ATGET

Postcards of a Lost Paris

SELECTIONS FROM THE
LEONARD A. LAUDER POSTCARD ARCHIVE

Benjamin Weiss

MFA PUBLICATIONS | MUSEUM OF FINE ARTS, BOSTON

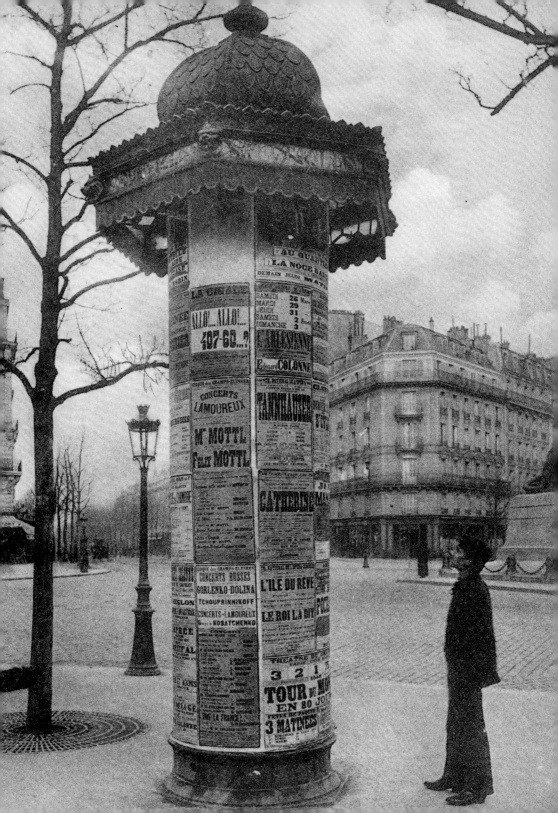

Atget before Atget

FEW PLACES ON EARTH have been as lovingly, perhaps obsessively, documented as the city of Paris. At the very moment when photography burst into the world in 1839, photographers turned their lenses on the city — and never turned away. Ever since, they have seemed intent on capturing every boulevard and building, every demolition and construction site, even every street sign and lamppost. Yet despite the change and growth traced so vividly in those millions of images, the Paris of the world's imagination is, to a remarkable degree, caught at one moment in time: the years around 1900. For many, Paris is still a place of Art Nouveau subway entrances, small shops with dusty and eccentric displays of peculiar objects, overflowing public markets, and walls bedecked with dizzying, overlapping collages of posters. It's a fantasy vision, for Paris has been just as subject to gentrification and displacement as any other world capital; but the idea of a place forever hanging elegantly at the edge of the nineteenth century, where people walk the streets with baguettes rather than smart phones, is powerful and persistent.

That imaginary Paris is to no small degree the work of Eugène Atget, whose photographs of the city have been reproduced and imitated almost to the point of cliché. Yet despite the near-complete identification of Atget with the city, the photographer was not a Parisian by birth, having come into the world in the town of Libourne, near Bordeaux, in 1857. After he failed to gain entrance to a military academy and spent an unhappy few years as a sailor, Atget moved to the capital in the late 1870s to attend the national conservatory for dramatic arts. He planned to be an actor, but like many aspiring thespians, his plans changed. He dropped out of school without a degree and washed out on the stage. Eventually,

in the 1880s, Atget took up photography, and, in that fitful way a hobby can slowly transform itself into a career, he became a fully professional photographer over the course of the 1890s.

Much of Atget's early work is difficult to trace, for he was a professional in the truest sense, selling photos of artworks and city scenes to other artists, who presumably used the images as a quick handmaiden to their own work. Yet Atget had grander ambitions as well. As the nineteenth century drew to a close, he began a project to make a systematic record of "old" Paris, a city that he saw as slipping away under the pressure of new ways. As he worked his way across the inner quarters of the city, capturing quiet street corners and old-fashioned shop windows, domestic interiors and courtyards, his photos came to the attention of libraries, including the Bibliothèque nationale and the Bibliothèque historique de la ville de Paris.

Like Atget, those institutions sought to preserve a visual record of a city that seemed in the process of changing beyond recognition. Beginning around 1900, they acquired large sets of Atget's images, which the photographer himself arranged into albums organized by category, such as Interiors, Transport, Trades, Stores, and Markets. The project was, in essence, a taxonomy of the city. Perhaps reflecting that documentary impulse, the images in these albums often have a dispassionate and almost eerie stillness, not least because they are nearly always unpopulated. Atget seemed to prefer Paris without the restless humans who were at the same time responsible for the very existence of the city he clearly loved and the source of the change he just as clearly regretted (fig. 1).

For most of his career, the images and albums that Atget sold to institutions were the primary way his work found an audience. Or, at least, they were the primary way we can trace, for especially in the early years Atget must have sold many photos that are now impossible to identify as being from his camera. The photographer left relatively few records, and while we know that the historians and archivists of the time valued

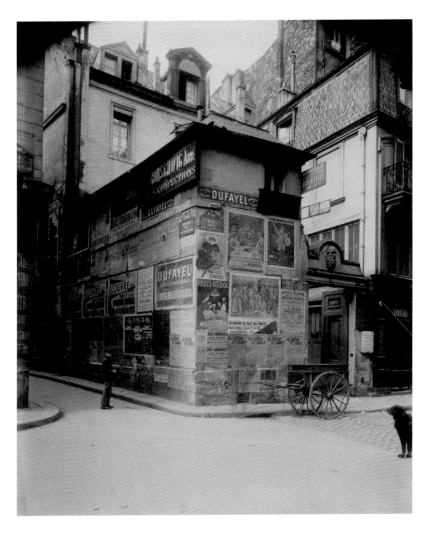

Fig. 1. Jean-Eugène Auguste Atget's *39, rue des Bourdonnais,
House of the Golden Beard*, about 1896

Je suis tres asseure que l'on ne scauroit voir, Elles me coustent bon, puis que pour les auoir,
Ny manger de long temps de meilleures escailles; Sur le bord du bateau j'ay donné des batailles.

Bosse inuen. et fe. le Blond excud auec Priuilege

Fig. 2. A mid-17th-century Parisian oyster seller by Abraham Bosse

Atget's systematic vision, we have little sense of his place in the larger art world. Fame came late. It was not until near the end of Atget's life that the Paris avant-garde turned its gaze toward the photographer. In the 1920s, Atget crossed paths with a group of expatriate Americans, including Man Ray and Berenice Abbott, who were drawn to the surreal poetry of his work. When the photographer died in 1927, Abbott acquired fully half of Atget's artistic estate, and she soon began to publish his negatives and promote his work. It was Abbott's books that really provided Atget his path to fame, as well as his entrée to the Museum of Modern Art, to which she sold her collection in the 1960s. Though a Parisian, Atget gained his place in the modernist pantheon by way of New York.

The postcards in this book, which were more or less Atget's only formal publications during his lifetime, come from near the beginning of his career. Produced most likely in 1904, the cards capture a cross section of Paris's *petits métiers*, the "little trades" and activities that enlivened the city streets, to the delight — and sometimes the disgust — of visitors. On the cards themselves the series is titled in an appropriately diminutive way, "*p'tits.*" Though these photos are different from the quiet and unpopulated scenes found in Atget's albums, the tripe merchants, pottery menders, street cleaners, and carnival barkers who populate them were just as much part of his project to capture the evanescent old city as his views of shop windows and street corners. Yet there is a difference. Atget's orderly, almost typological views were relatively novel, having few direct antecedents in the history of photography or art more generally (one possible exception being the photographically illustrated commercial trade catalogues that abounded in the later nineteenth century). Making images of tradespeople and workmen, however, was not new; rather, it grew out of a long and very distinguished tradition.

The idea that it is possible to capture the character of a place by depicting the people who ply their trades in the streets is an old one, with roots that stretch back to the Renaissance. As early as the 1520s, the

composer Clément Janequin wrote a clever series of polyphonic songs using the cries and calls—the vocal advertisements—of Parisian merchants, each overlapping with the next just as they did as one walked through the streets. In the seventeenth and eighteenth centuries, publishers issued many sets of prints meant to document the picturesque characters of the city, from respectable merchants and booksellers to ratcatchers and ragmen. Usually, these prints would show the costumes tradespeople wore and transcribe the cries they used to hawk their wares and advertise their skills (figs. 2, 3, and 4).

There must have been a strong market for such images, for it seems that every few years another set of Parisian cries would come off the presses. Nor was Paris the only city whose street life was commemorated in print. Artists and publishers captured the trades of London, Venice, Rome, and nearly every other major European city in much the same way. Cries were taken to be part of the distinctive flavor of a place, and they wove themselves into the shared memory of the premodern city. A few even live on today. The ballad of sweet Molly Malone, with her "cockles, and mussels, alive, alive, oh!," still sung occasionally in pubs across Ireland, is but the distant echo of a Dublin street cry. Paradoxically, many of these printed collections of trades and cries, which mostly showed the ragged and lowly, were quite deluxe and elegantly packaged. In the mid-eighteenth century, the porcelain manufactory at Meissen issued a series of ceramic *petits métiers*; the exquisite porcelain tradesmen graced tables and shelves in elegant mansions whose owners would likely never have welcomed their living, breathing counterparts.

These printed collections of trades and cries flourished throughout the nineteenth century, even as rapid urban growth, industrialization, and the increasing regulation of trade drained cities of some of their traditional character and color. Food sellers were gathered into neatly ordered markets; old neighborhoods were rebuilt, and vast new ones, their streets carefully laid out with demarcated spaces for pedestrians and

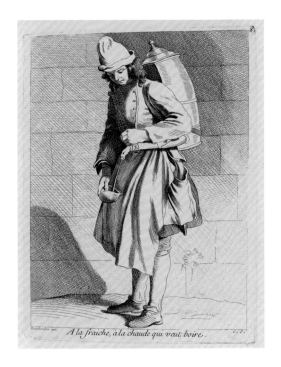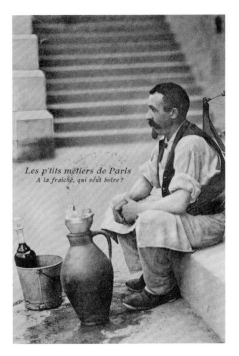

Figs. 3 and 4. *Cold drinks! Hot drinks! Who wants a drink?*, from Edmé Bouchardon's 18th-century *Cries of Paris*, and Atget's echo of that cry.

carriages, brought a different sort of order to traffic and public life. The glittering modern Paris of the 1880s and '90s, with its broad boulevards, gas and electric lights, and indoor plumbing, was a very different place from the city of the 1840s, with its ancient and tangled streetscape. Writers began to frame their essays on street cries and trades with laments about the passing of the old ways and the old sights, and an air of nostalgia came to hang around the genre. Yet the tradition endured, presented sometimes as an exercise in memory, but just as often reinvented, with a revised cast of characters for a new age. Yes, there were fewer ratcatchers and rag collectors in the new collections, but now there were newspaper sellers, ice-skating instructors, dog groomers, and stock market scam

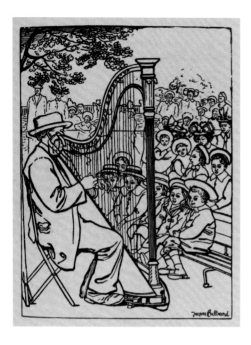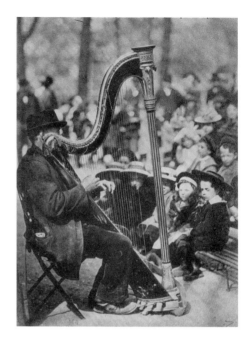

Figs. 5 and 6. Jacques Beltrand based his 1904 wood engraving of a harp player in the Luxembourg Gardens directly on Atget's postcard photograph.

artists.[1] Indeed, the years around 1900 saw a renewed flood of publications — in words and pictures — about the fascinating personalities one might encounter in Paris's streets.

So in 1898, when Atget began a large series of photographs of tradespeople and street sellers, he was both drawing on a long tradition and contributing to one that had clear commercial possibilities.[2] And whatever Atget's larger artistic ambitions, which were then coming into focus, he did need to make a living. So it is not surprising that images from his petits métiers found their way into print in more than one form. Between 1900 and 1904 the artist and publisher Jacques Beltrand used some of Atget's photos as sources for his illustrations to a collection of trades, Tristan Klingsor's *Petits métiers des rues de Paris*.[3] Beltrand did

not reproduce Atget's photos exactly; instead, he used them (without attribution) as the source for simple outline illustrations, which he cut as wood engravings (figs. 5 and 6). The book was elegant and expensive, printed on high-quality paper, and aimed at collectors of fine prints and limited editions, for which the publisher even supplied extra copies of the illustrations in an accompanying portfolio. Beltrand targeted the high end of the market, but in the very same years, Atget's images found a completely different home as well — on picture postcards.

The years just around 1900 were the very peak of the international postcard craze, when nearly everyone seemed to collect postcards, and each year billions upon billions of cards passed through the mails or were stashed in albums. Collectors were always avid for novelties, and publishers eager to feed that hunger. Subjects like the petits métiers were ideal, for postcard collectors especially relished the idea of sets and series. Sets that showed a sort of human taxonomy — ethnic types, traditional costumes, crafts and trades — were popular around the world, and publishers issued a seemingly infinite number of series in response to that demand. We do not know if the publisher, Victor Porcher, issued his suite of 80 petits métiers postcards (selected from a much larger group of photos by Atget) all at once or released a few at a time, to keep the collectors' desire at a simmer. Either way, Porcher made sure that truly obsessed collectors would not stop at just 80 cards. He issued the series in two formats: one in simple black and white, and, presumably for a slightly higher price, one with hand coloring. The true completist would need all 160 cards. The cards reproduced in this book include examples of both kinds.

Sadly, we do not know the origin of the postcard series. No records of the project seem to have survived from either Atget or Porcher; nor is there much information to be gleaned from Porcher's other postcards, which run to standard views of French scenes and places. We do not know whether Porcher approached Atget or the other way around, or who chose the images for the set. Atget's name does not appear on the

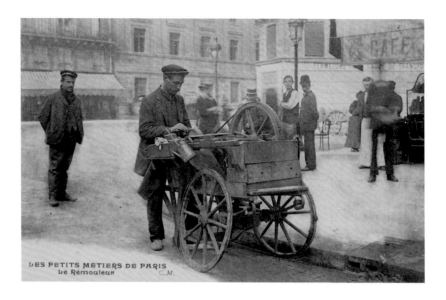

LES PETITS MÉTIERS DE PARIS
Le Rémouleur C.M.

Fig. 7. Compare this knife grinder from C. Malcuit's postcard series
with Atget's near contemporary version (no. 47).

cards, though they can be attributed to him based on the images' over-
laps with his larger series of petits métiers. The only other near certainty
is that the cards came to market in 1904, though that information, too,
comes from external evidence, for the cards bear no copyright date. The
clues lie on the backs. Some bear postmarks of 1904, so the set must
have been at least begun by then, and the fact that all the cards have
"divided backs" means they cannot predate that year. For that was when
the French postal service first allowed postcards that resemble those we
still have today, with one half of the back reserved for the message and
the other for the address. Before 1904, the back of the card could bear
only the address.

Whatever the cards' genesis, Porcher was clearly responding to a
demand in the postcard market. At least five other publishers issued
similar series of petits métiers in these years, and the sets make for an

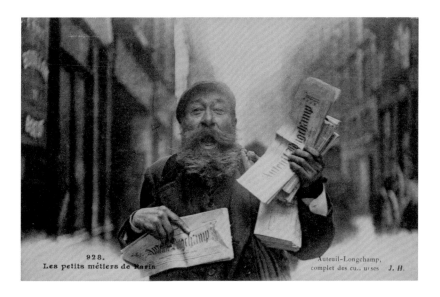

928.
Les petits métiers de Paris

Auteuil-Longchamp,
complet des cu.. ur ses J. H.

Fig. 8. *Auteuil-Longchamp, complete race results* shows a newspaper hawker
from J. Hauser's series *The Little Trades of Paris*.

interesting comparison. Most contain at least some of the same trades, but each series takes a slightly different approach. All contain fascinating and lively images, so the differences are not a matter of quality as much as of sensibility. In his set, for example, C. Malcuit takes an almost strictly documentary approach. He captures everyday scenes in an everyday, even deadpan way (fig. 7). The result is a kind of typology, a sort of *Peterson Field Guide* to the trades. J. Hauser's views, by contrast, tend to be lively, almost stagey dramas, as if Hauser was trying to capture the visceral effect of the moment when a visitor to Paris might have an encounter on the street. Many of Hauser's subjects engage directly with the camera—they look straight at us—and he often invests the scene with a sense of arrested motion. Some of Hauser's cards are quite explicit in their evocation of cries, as well. His newspaper vendor, for example, seems almost to yell at us from the card: "Auteuil-Longchamp, complete race results!" (fig. 8).

Fig. 9. Detail of no. 37

Atget's trades are different. His scenes tend to be quieter, and his subjects less concerned with us; they rarely look directly at the camera, even though the scenes were almost certainly posed. It is as if Atget wants to invest the series with a certain sidelong informality — a casual everydayness — so that the overall effect of the group is less that of a catalogue of the city's human fauna than of a collection of memories gathered during an exploratory stroll. Atget's mix of subjects is a little odd as well. Like the other photographers, he includes new trades as well as old ones, sometimes posing the older trades, like the ragman and the lace seller, in ways that seem suspiciously reminiscent of the seventeenth- and eighteenth-century print models he must have known. But while the other postcard series hew close to tradition in showing people at work, quite a number of Atget's "trades" are no such thing. The man resting his head because it is "a little too hot" is not working, he is just hot; and the scenes of the puppet show are about the audience, not the puppeteer — they don't even include the performer (fig. 9; see no. 52).

The gentle tone and overall dispassion that govern the series mean that Atget's subjects are neither specimens nor freaks; instead, they appear to stand for a larger civic culture and experience. The entire project seems to be an essay about life in the city.

The seesaw between old and new, tradesman and consumer, that plays out across the series is echoed in the postcards' captions. Some cards carry straightforward descriptions of the scene: "Parisian asphalt — Heating the bitumen" or "The pottery and porcelain mender"; others, in another echo of earlier print series, include the calls themselves: "Watercress, good for your health!" (see nos. 34, 17, and 29). The overall effect rocks back and forth between what one sees as one walks the street and what one hears. When viewed from beginning to end, the cards present a multi-sensory experience of the city. Whether or not that was intentional, and whether it was Atget's choice or Porcher's, we will likely never know.

The petits métiers are about people, but even in this series Atget includes a few scenes that contain no human figures at all. One of the most poetic cards is about a flower seller. Atget presents us with a street-corner kiosk covered with posters for chocolate, wines, and aperitifs; there are two wicker baskets out front, and a grand array of bouquets (see no. 30). The seller is nowhere to be seen, yet the card's caption is not a description; instead, it is the absent hawker's cry: "Holiday bouquets. Long live the day of Saint" The scene is about expectation and evocation, about mental echoes. And there, for just a moment, is the later Atget, the chronicler of quiet streets, surreal shop windows, and haunted gardens.

1. Guy Tomel [Gabriel Guillemot], *Petits métiers parisiens* (Paris: Charpentier, 1898).
2. Sophie Grossiord and Françoise Reynaud, *Atget, Géniaux, Vert: Petits métiers et types parisiens vers 1900*, exh. cat. (Paris: Musée Carnavalet and Paris Audiovisuel, 1984), 15, 33–37.
3. Tristan Klingsor, *Petits métiers des rues de Paris* (Paris: Jacques Beltrand, 1904); Grossiord and Reynaud, *Atget, Géniaux, Vert*, 15–16.

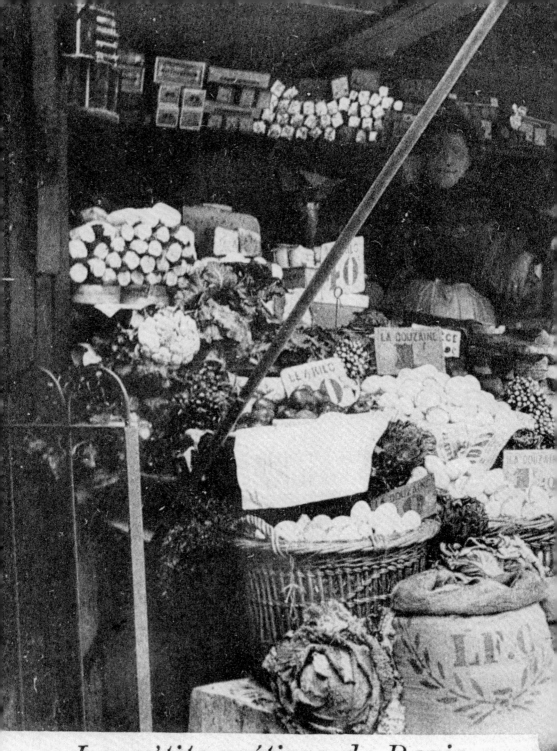

Les p'tits métiers de Paris
Sous la baraque — Primeurs et légumes secs

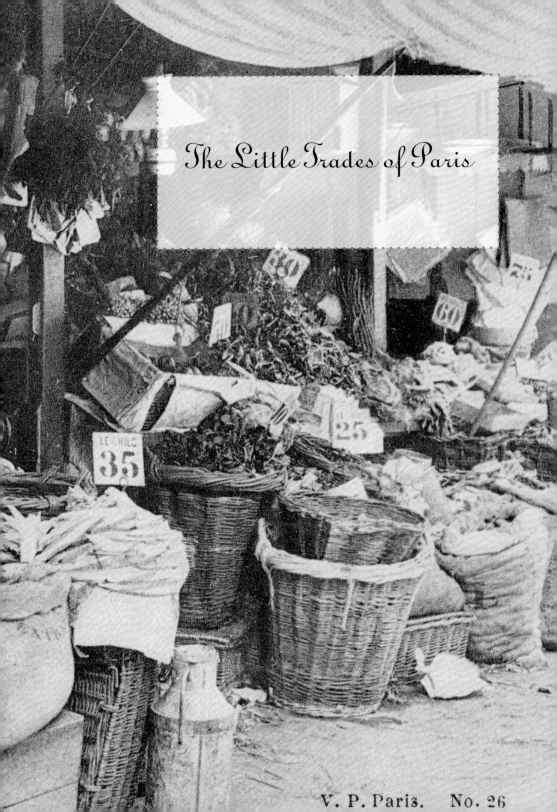

The Little Trades of Paris

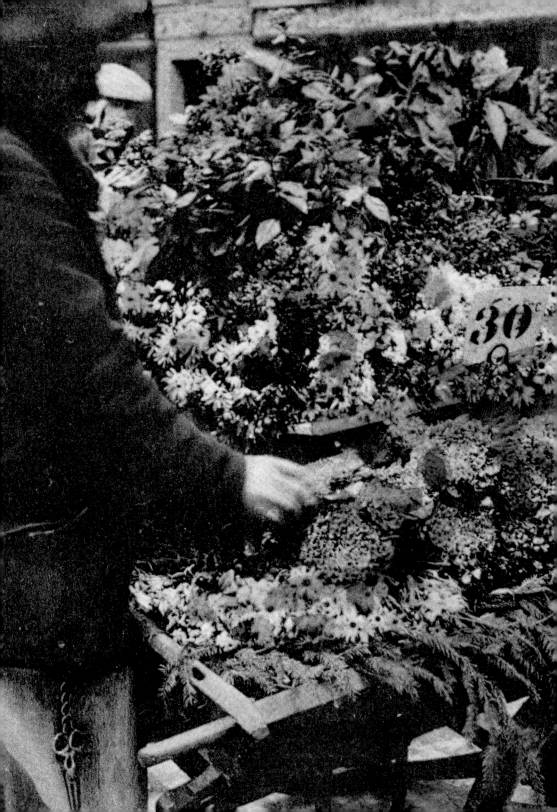

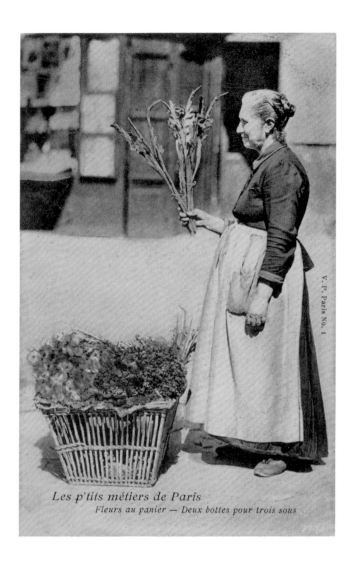

Les p'tits métiers de Paris
Fleurs au panier — Deux bottes pour trois sous

V. P. Paris No. 1

..

1 │ *Flowers for sale — Two bunches for three sous*

Wandering street vendors often carried their wares in baskets, which is why

they are sometimes called *marchands au panier*, or "basket sellers."

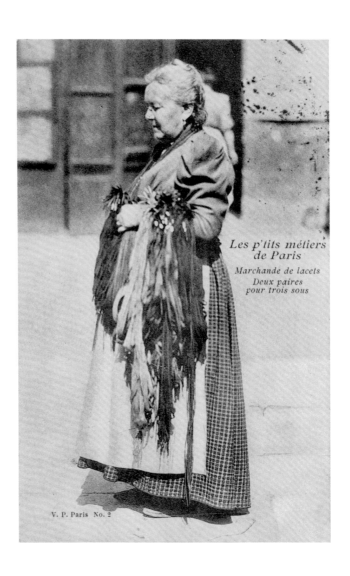

Les p'tits métiers
de Paris

Marchande de lacets
Deux paires
pour trois sous

V. P. Paris No. 2

..

2 │ *Lace seller. Two pairs for three sous.*

Atget's images were not casual snapshots. He photographed this lace seller and
the flower seller in the previous image in precisely the same pose and place.

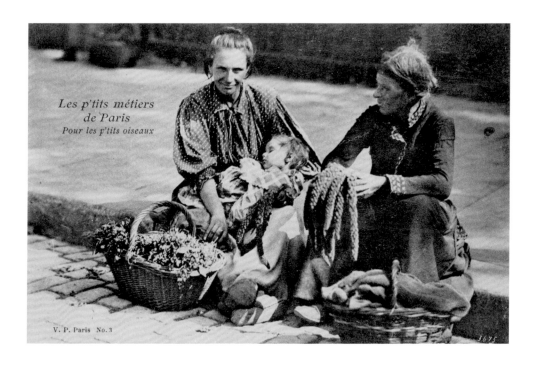

Les p'tits métiers
de Paris
Pour les p'tits oiseaux

V. P. Paris No. 3

......................................

3 | *For the little birds*

Some street vendors offered small packets of seed or plants
for those who wished to feed the birds.

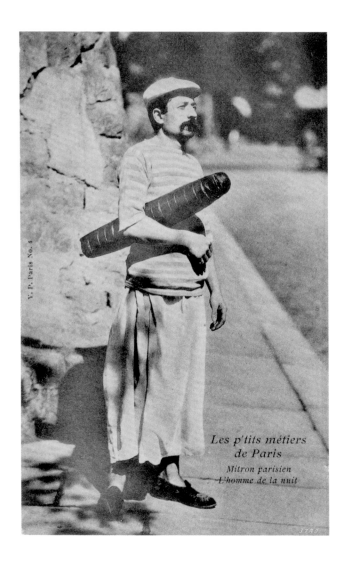

Les p'tits métiers
de Paris
Mitron parisien
L'homme de la nuit

V. P. Paris No. 4

4 | *Parisian baker. A man of the night*

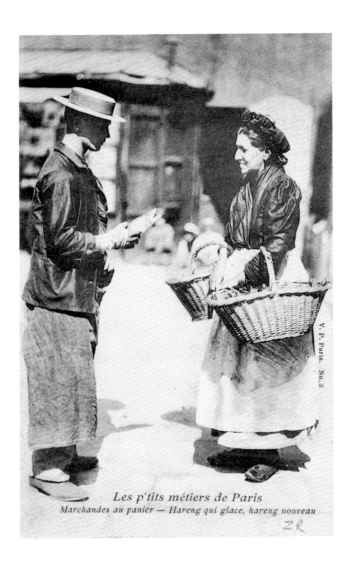

Les p'tits métiers de Paris
Marchandes au panier — Hareng qui glace, hareng nouveau

5 | *Street vendor—Frozen herring, fresh herring*

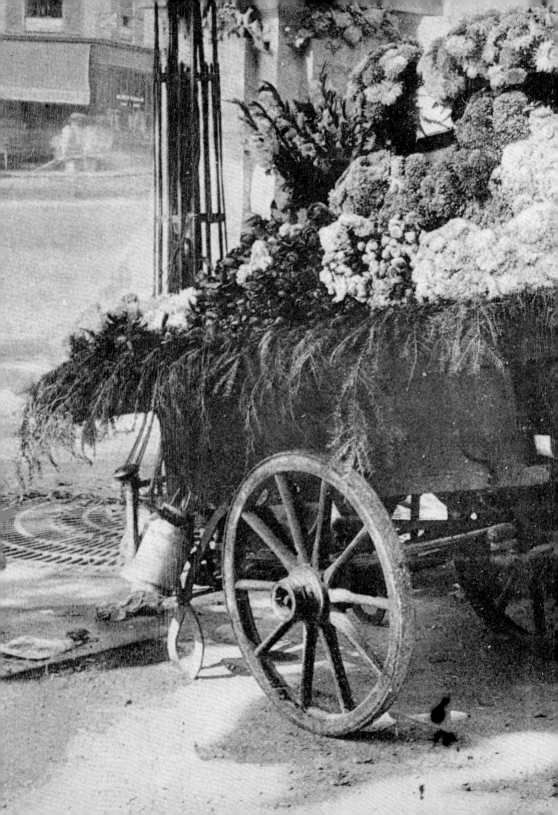

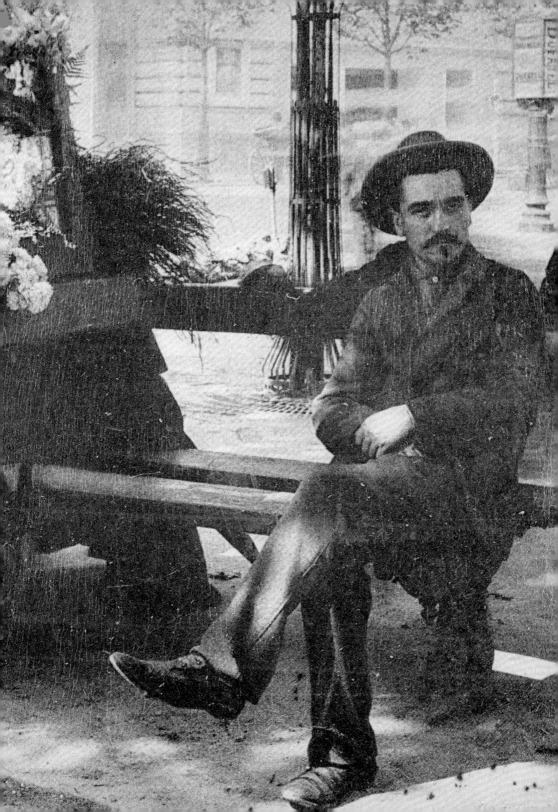

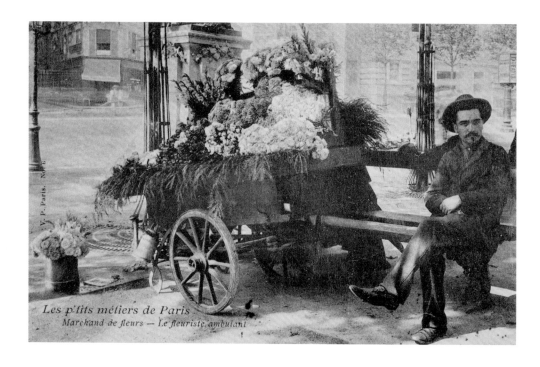

Les p'tits métiers de Paris
Marchand de fleurs — Le fleuriste ambulant

6 | *Flower seller — The mobile florist*

The man washing down the street in front of an awning
suggests that this may be an early-morning scene.

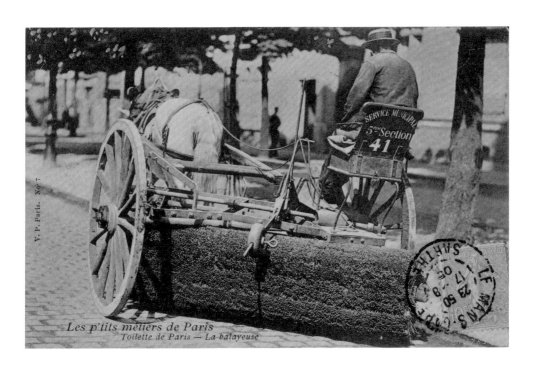

Les p'tits métiers de Paris
Toilette de Paris — La balayeuse

7 | *Grooming Paris — The street sweeper*

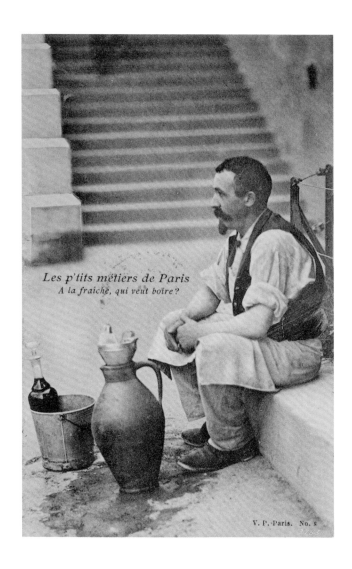

Les p'tits métiers de Paris
A la fraiche, qui veut boire ?

V. P. ·Paris. No. 8

..

8 | *Cold drinks! Who wants a drink?*

The captions on Atget's cards usually describe the scene depicted, but sometimes, as here, they consist simply of an associated call or cry.

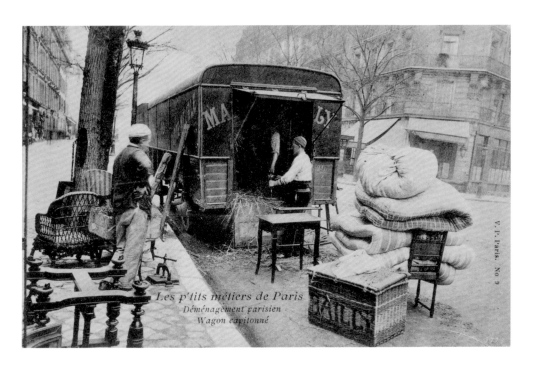

Les p'tits métiers de Paris
Déménagement parisien
Wagon capitonné

V. P. Paris. No 9

9 | *Paris on the move. A padded wagon.*

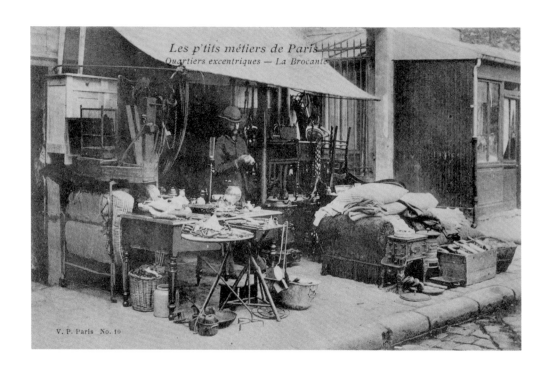

Les p'tits métiers de Paris
Quartiers excentriques — La Brocante

V. P. Paris No. 10

10 | *Outer quarters — Thrift shop*

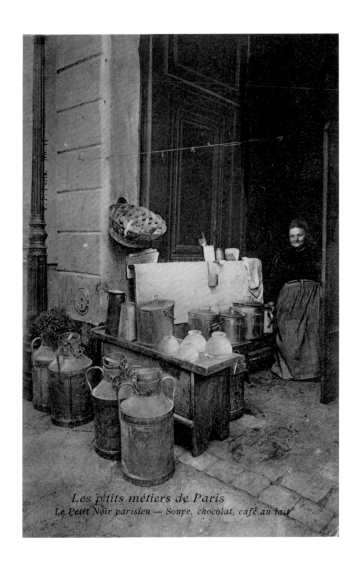

Les p'tits métiers de Paris
Le Petit Noir parisien — Soupe, chocolat, café au lait

11 | *Parisian street café — Soup, hot chocolate, café au lait*

The artists who colored postcards worked fast, as revealed by the imprecise edge
on the bench and the quick daubs of yellow on the jars.

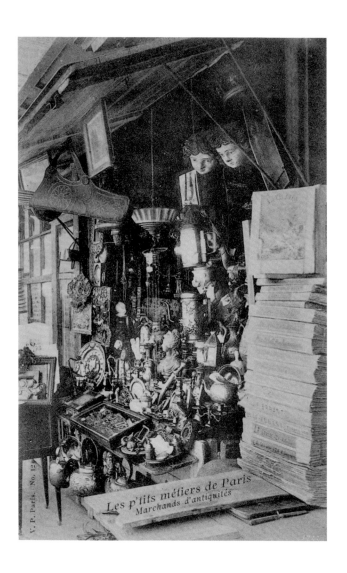

Les p'tits métiers de Paris
Marchands d'antiquités

V. P. Paris. No. 12

12 | *Antique sellers*

Atget's taste for surreal juxtapositions comes out in this scene,
with its oddly hovering heads. The pile of books at right includes
serialized novels by writers such as Eugène Sue.

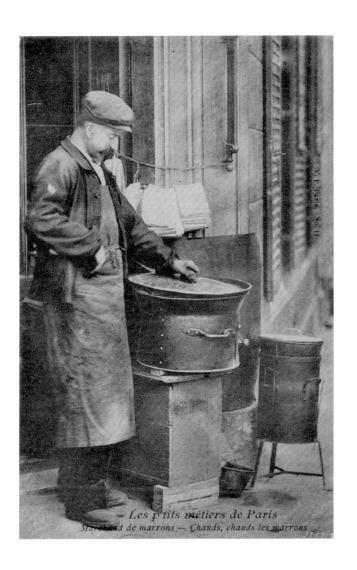

Les p'tits métiers de Paris
Marchand de marrons — Chauds, chauds les marrons

...

13 | *Chestnut seller — Hot, hot chestnuts*

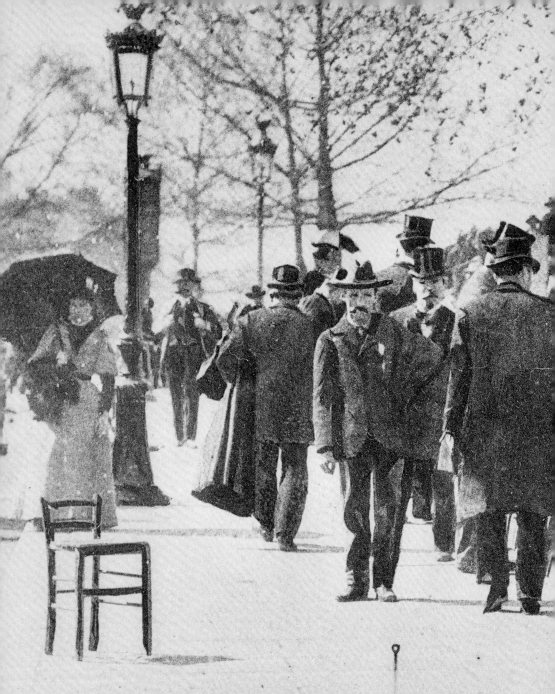

Les p'tits métiers de Paris
Sur les quais — Les bouquini...

V. P. Paris. No. 14

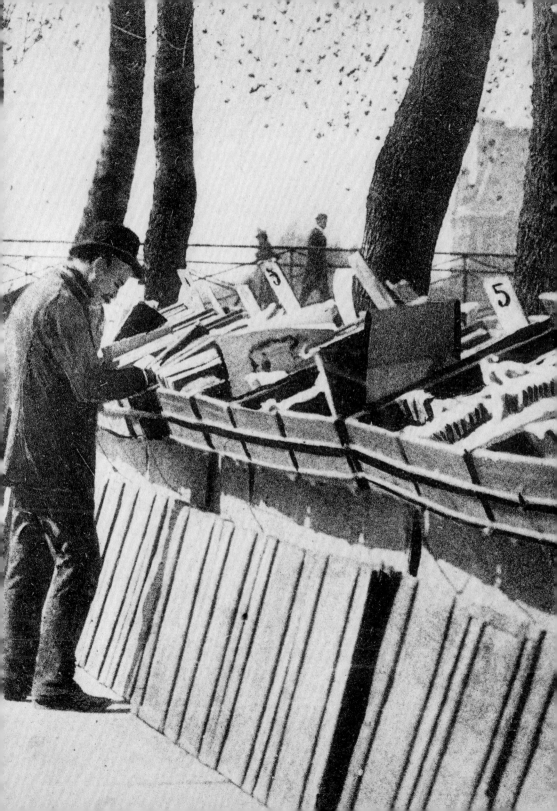

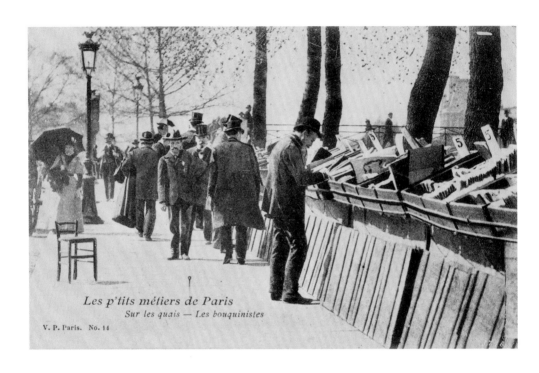

Les p'tits métiers de Paris
Sur les quais — Les bouquinistes

V. P. Paris. No. 14

14 | *Along the quays — The booksellers*

Even at the turn of the century, the banks of the Seine were famous
for being lined with booksellers' stalls.

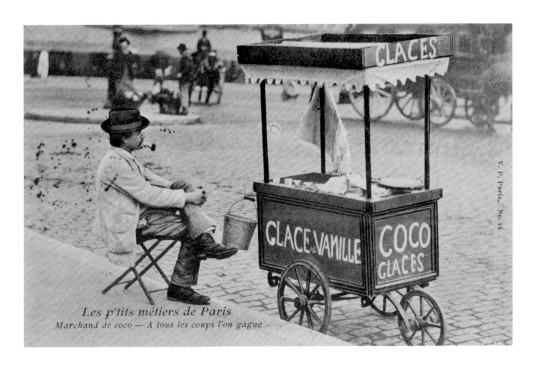

Les p'tits métiers de Paris
Marchand de coco — A tous les coups l'on gagne

15 | *Ice cream seller — A winner every time*

It is not clear whether the advertisements for vanilla and coconut ice
were actually painted on the cart or if the publisher wrote
the words on the photographic negative.

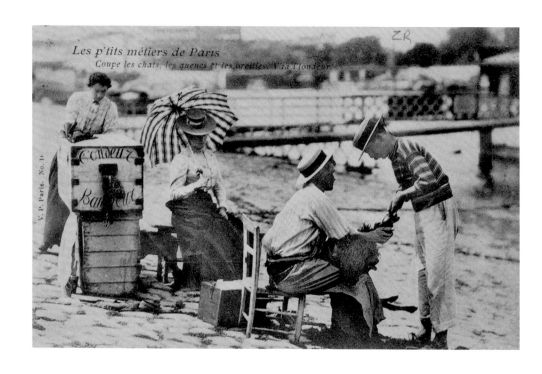

Les p'tits métiers de Paris
Coupe les chats, les queues et les oreilles. V'la l'tondeur

..

16 | *Cutting cats, tails, and ears. Here's the shearer.*

This is the call of the tradesman who docks pets' tails,
crops their ears, and neuters cats and dogs.

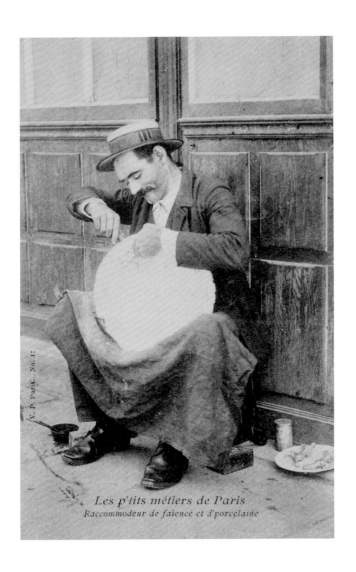

Les p'tits métiers de Paris
Raccommodeur de faïence et d'porcelaine

..

17 | *The pottery and porcelain mender*

The figure of a pottery mender appears in nearly every series of little trades.
This man appears to be bending the small metal staples
that hold the broken pieces together.

Les p'tits métiers de Paris

Coupe les chats, les queues et les ore

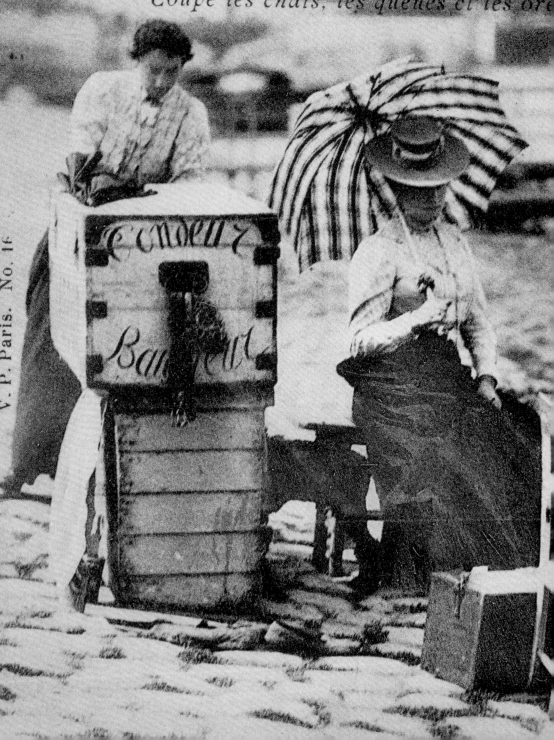

V. P. Paris. No. 16

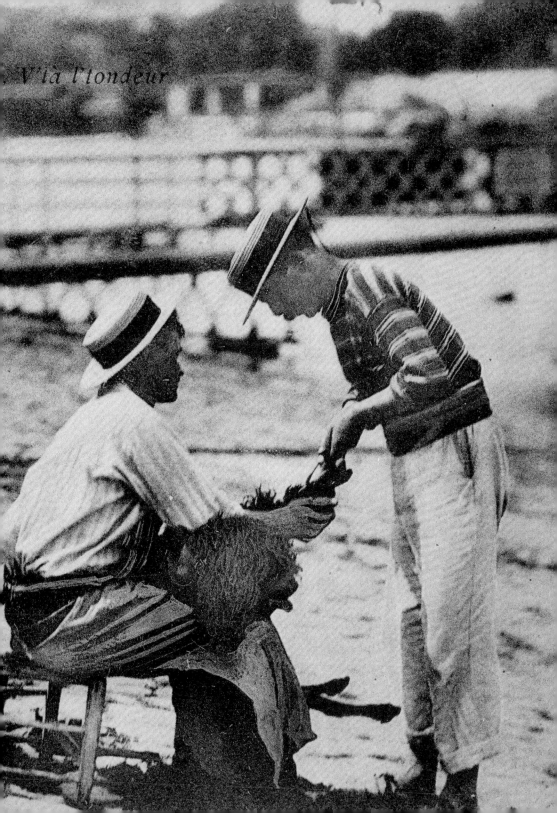

V'là l'tondeur

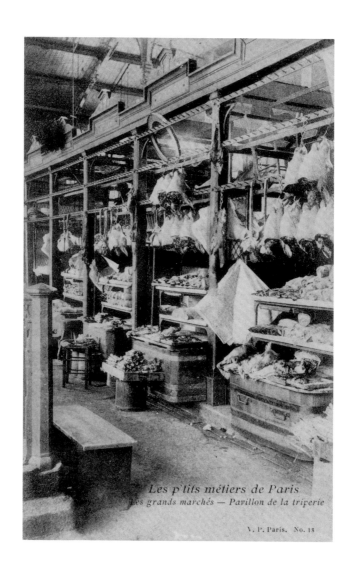

Les p'tits métiers de Paris
Les grands marchés — Pavillon de la triperie

V. P. Paris. No. 18

.......................................

18 | *The big market — Tripe and offal pavilion*

The vast iron-and-glass structure called "the big market" here
was known as Les Halles, Paris's central food market
and a major tourist attraction for many decades.

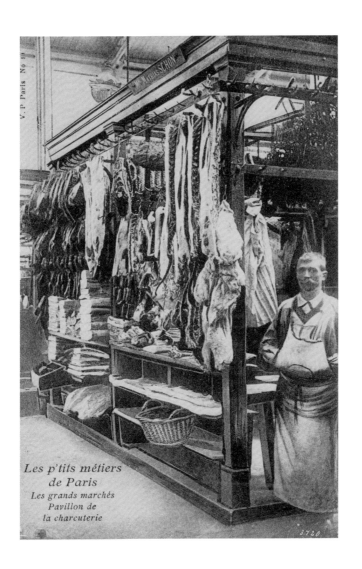

Les p'tits métiers
de Paris
Les grands marchés
Pavillon de
la charcuterie

19 | *The big market — Charcuterie pavilion*

The grand structure of Les Halles was divided into pavilions,
each dedicated to a different kind of food.

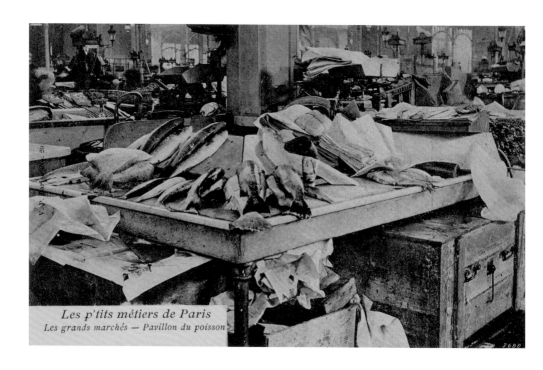

Les p'tits métiers de Paris
Les grands marchés — Pavillon du poisson

20 | *The big market — Fish pavilion*

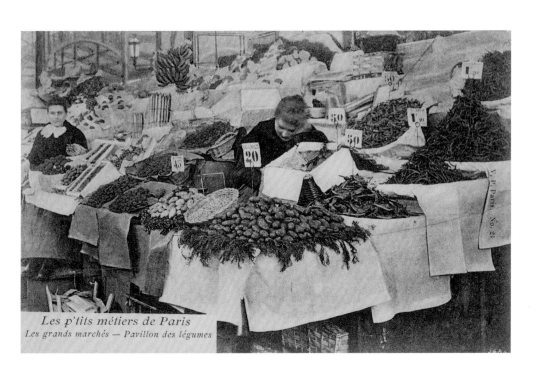

Les p'tits métiers de Paris
Les grands marchés — Pavillon des légumes

..

21 | *The big market — Vegetable pavilion*

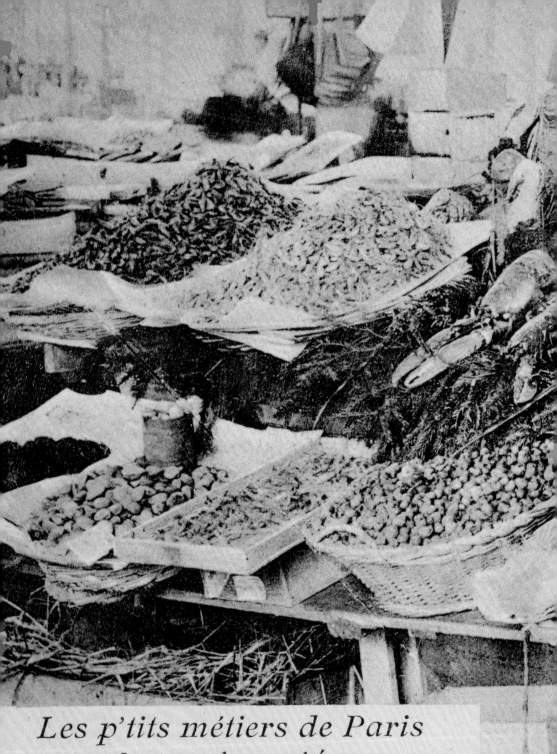

Les p'tits métiers de Paris
Les grands marchés
Pavillon de la Poissonnerie

P. Paris. No. 23

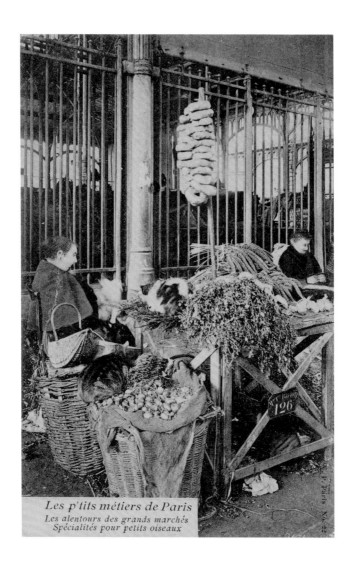

Les p'tits métiers de Paris
Les alentours des grands marchés
Spécialités pour petits oiseaux

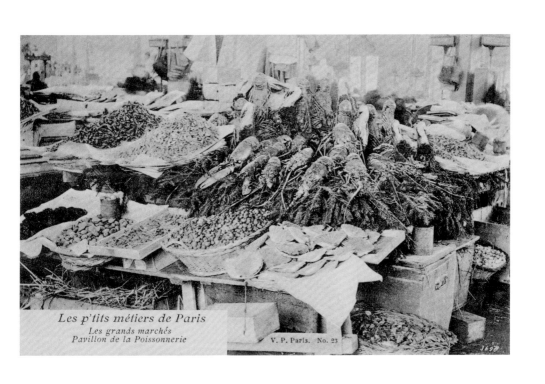

Les p'tits métiers de Paris
Les grands marchés
Pavillon de la Poissonnerie

V. P. Paris. No. 23

23 | *The big market — Fish pavilion*

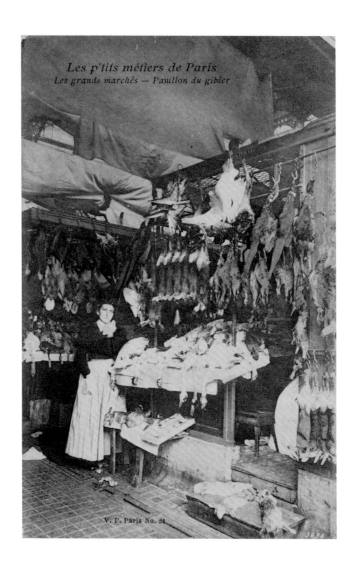

Les p'tits métiers de Paris
Les grands marchés — Pavillon du gibier

V. P. Paris No. 24

24 | *The big market — Game pavilion*

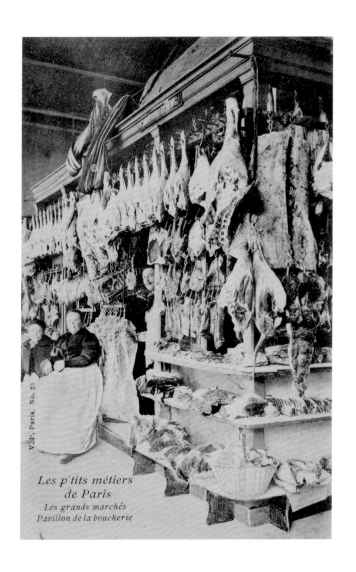

Les p'tits métiers
de Paris
Les grands marchés
Pavillon de la boucherie

│ *The big market — Meat pavilion*

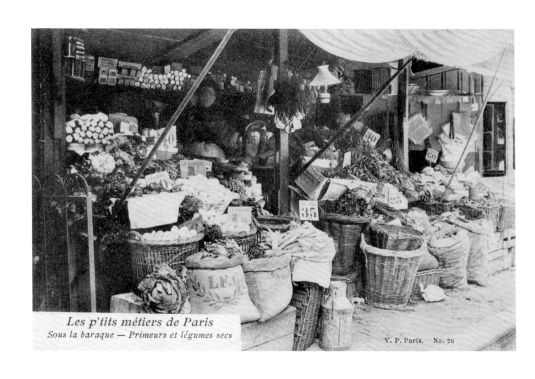

Les p'tits métiers de Paris
Sous la baraque — Primeurs et légumes secs

V. P. Paris. No. 26

26 | *Under the awning — Fresh vegetables and dried beans*

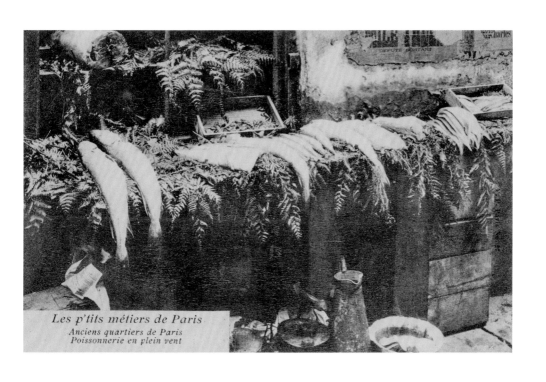

Les p'tits métiers de Paris
Anciens quartiers de Paris
Poissonnerie en plein vent

27 | *Old quarters of Paris. Open-air fishmonger*

Les p'tits métiers de Paris

Anciens quartiers de Paris
Poissonnerie en plein vent

DÉPUTÉ SORTANT

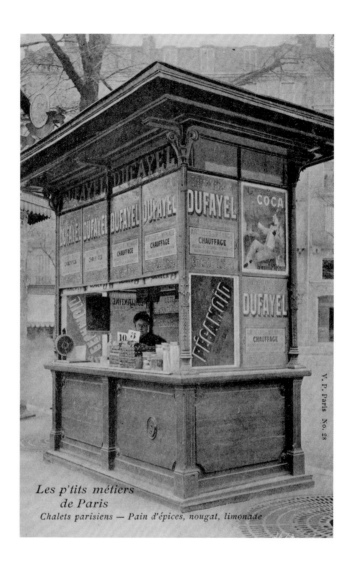

Les p'tits métiers
de Paris

Chalets parisiens — Pain d'épices, nougat, limonade

V. P. Paris No. 28

28 | *Parisian kiosks — Gingerbread, nougat, lemonade*

The Grands Magasins Dufayel, whose advertisements plaster this kiosk,
was among the largest Parisian department stores.

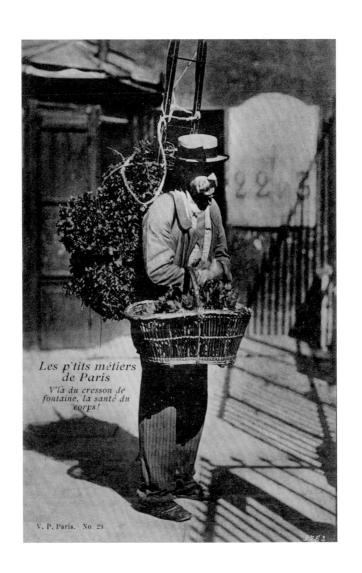

Les p'tits métiers
de Paris

V'là du cresson de
fontaine, la santé du
corps!

V. P. Paris. No. 29

29 | *Watercress, good for your health!*

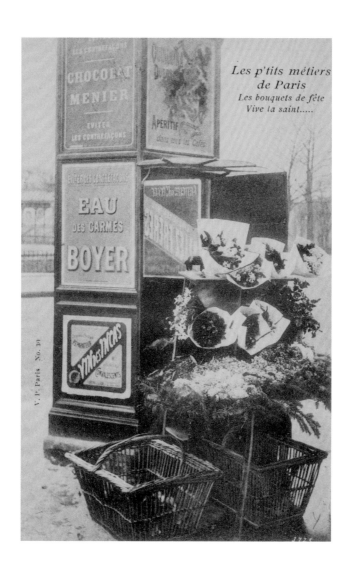

30 | *Holiday bouquets. Long live the day of Saint . . .*

The practice of leaving bouquets in churches and offering flowers
to celebrants on their saints' days helped support a plethora
of small florists' stands throughout the city.

Les p'tits métiers de Paris
Baʒar en plein vent — Plaisir des petits enfants

31 │ *An open-air shop — The joy of little children*

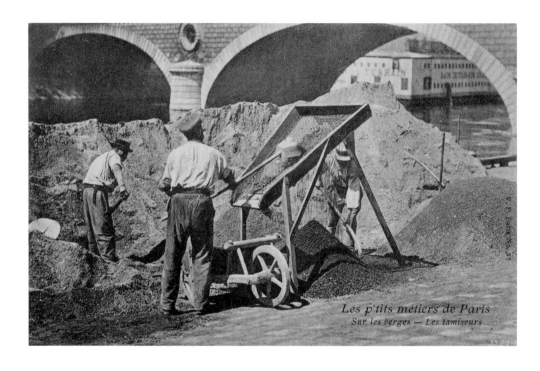

Les p'tits métiers de Paris
Sur les berges — Les tamiseurs

...

32 | *On the riverbank — The sifters*

This is the first of a series of views showing the construction
and care of the city's paved streets. These workers
sift the sand needed for laying cobblestones.

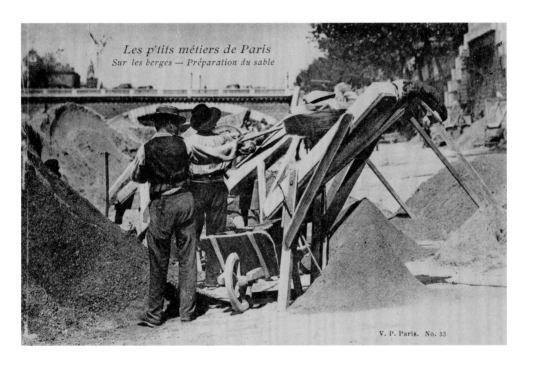

Les p'tits métiers de Paris
Sur les berges — Préparation du sable

V. P. Paris. No. 33

33 │ *On the riverbank — Preparation of sand*

Atget captured a road crew working near the Pont Louis-Philippe,
which links the Right Bank and the Île Saint-Louis.

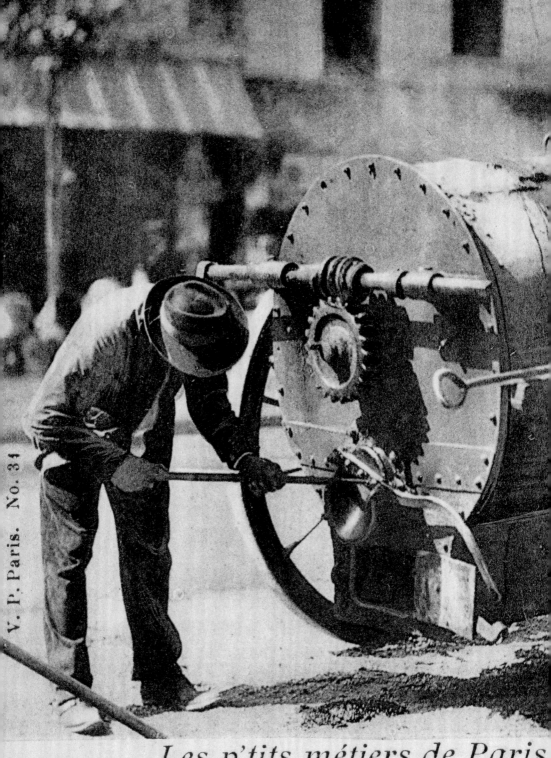

Les p'tits métiers de Paris

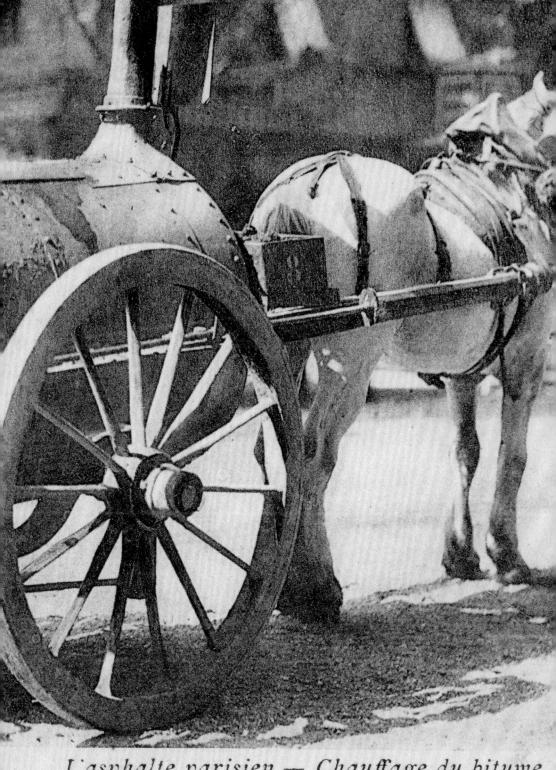

L'asphalte parisien — Chauffage du bitume

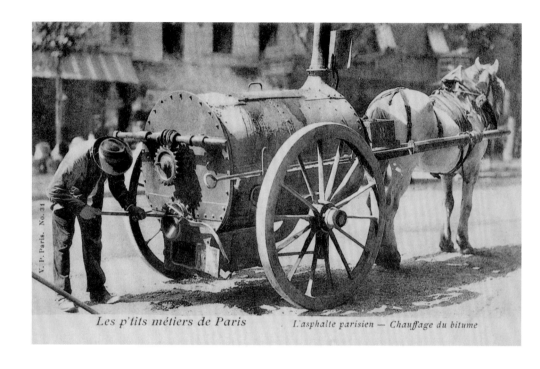

Les p'tits métiers de Paris L'asphalte parisien — Chauffage du bitume

....................................

3 4 | *Parisian asphalt—Heating the bitumen*

Around 1900 Paris was famous for its up-to-date asphalt
(or bitumen) pavement; the novel street surface
was an object of some fascination.

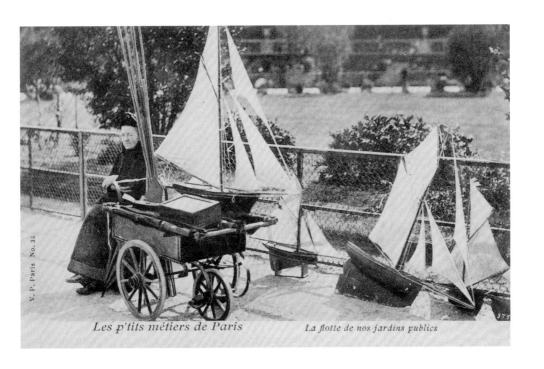

Les p'tits métiers de Paris *La flotte de nos jardins publics*

....................................

35 | *The fleet of our public parks*

In some Parisian parks, those who do not own
a toy sailboat can rent one.

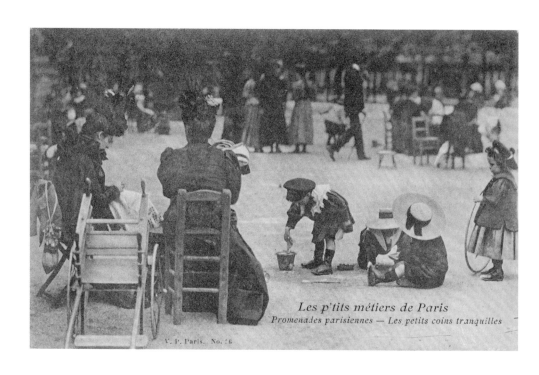

Les p'tits métiers de Paris
Promenades parisiennes — Les petits coins tranquilles

V. P. Paris. No. 16

36 | *Parisian promenades — Quiet little corners*

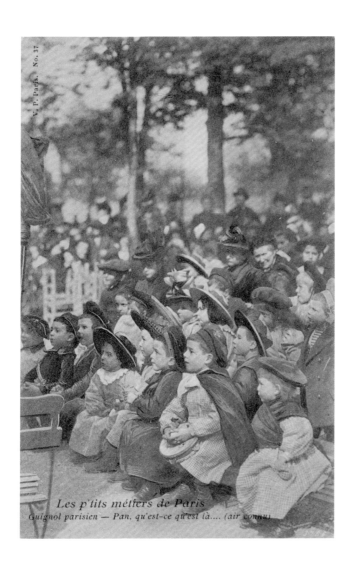

Les p'tits métiers de Paris
Guignol parisien — Pan, qu'est-ce qu'est là.... (air connu)

......................................

37 | *The Parisian Guignol — Pan, what's there . . . (a well-known tune)*

The puppet theaters that dot Paris's parks often feature shows that tell of the
adventures of Guignol, a silk weaver. This card's caption features
the first line of a popular refrain from the plays.

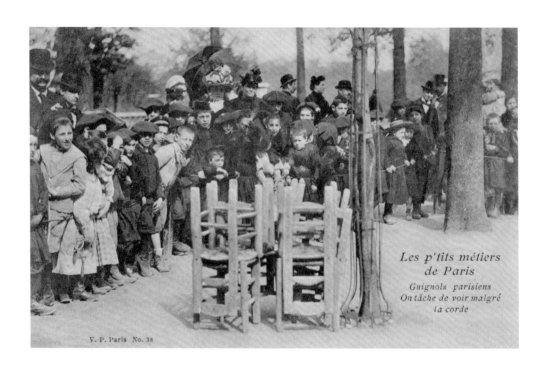

Les p'tits métiers
de Paris
Guignols parisiens
On tâche de voir malgré
la corde

V. P. Paris No. 38

. .

38 | *The Parisian Guignol — Trying to see from behind the rope*

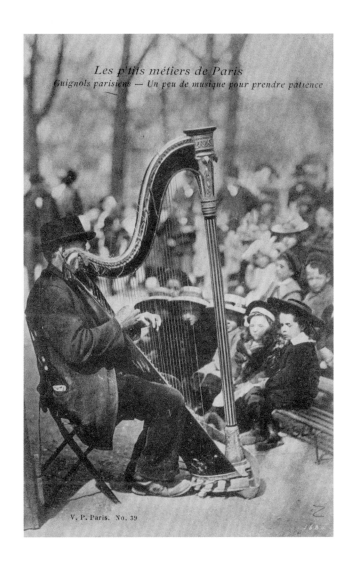

Les p'tits métiers de Paris
Guignols parisiens — Un peu de musique pour prendre patience

V. P. Paris. No. 39

......................................

39 | *The Parisian Guignol—A little music to ease the wait*

This image lived a second life in a wood engraving by Jacques Beltrand (see fig. 5).

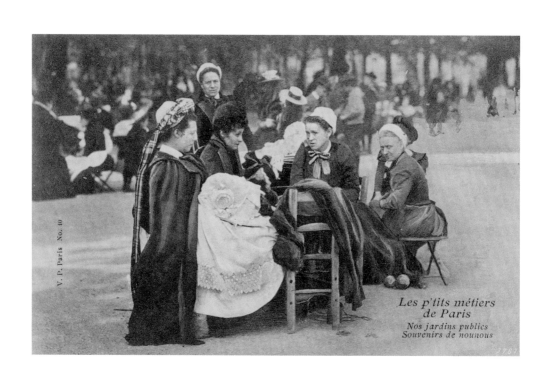

Les p'tits métiers
de Paris
Nos jardins publics
Souvenirs de nounous

40 | *Our public parks. Memories of the nannies*

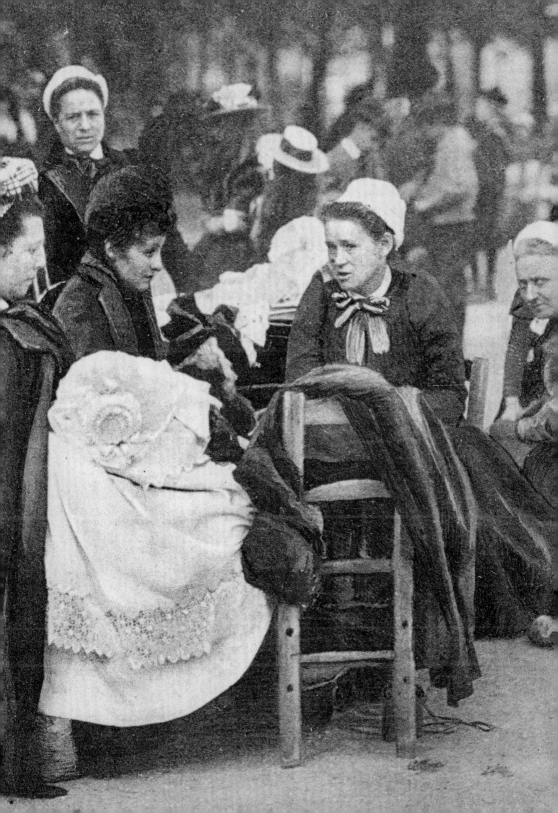

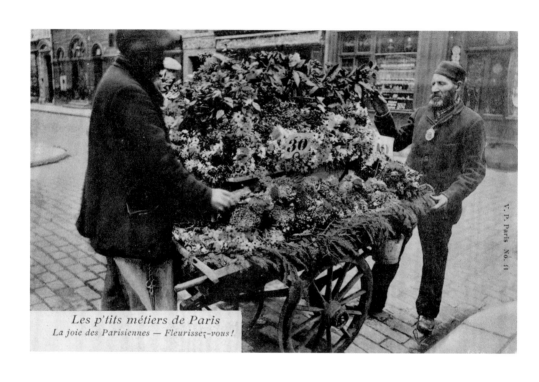

Les p'tits métiers de Paris
La joie des Parisiennes — Fleurisse-vous!*

V. P. Paris No. 41

41 | *Parisian ladies' joy—Deck yourselves in flowers!*

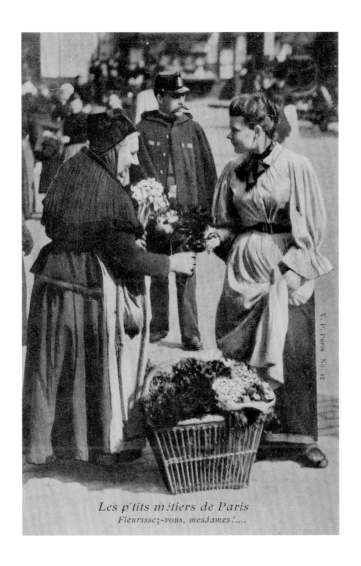

Les p'tits métiers de Paris
Fleurissez-vous, mesdames!....

...

42 | *Deck yourselves in flowers, ladies! . . .*

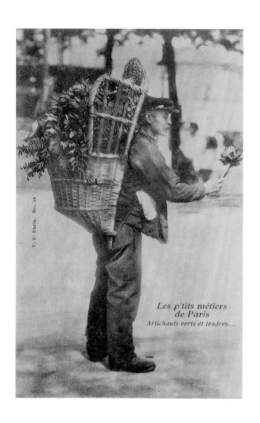

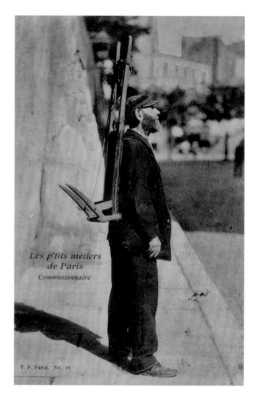

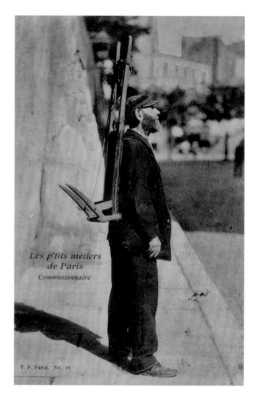

.......................................

43 | *Green and tender artichokes . . .*

44 | *Errand boy*

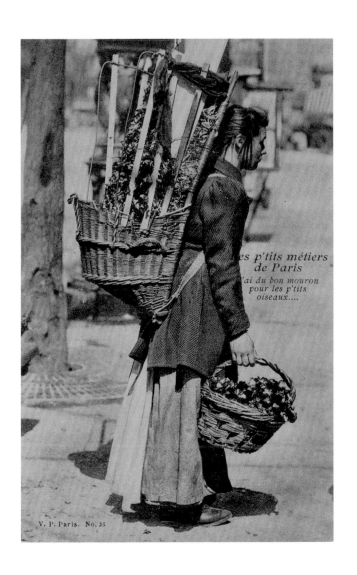

es p'tits métiers
de Paris

'ai du bon mouron
pour les p'tits
oiseaux....

V. P. Paris. No. 45

..

45 | *I have good chickweed for little birds. . . .*

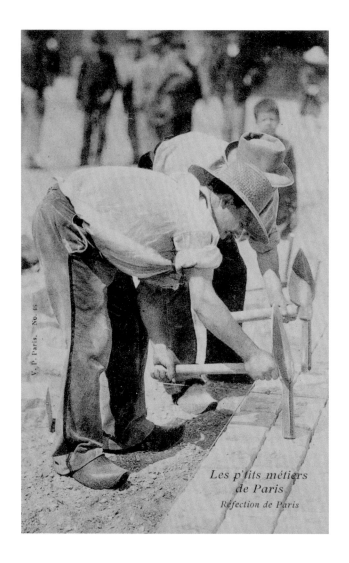

V. P. Paris. No. 46

Les p'tits métiers
de Paris
Réfection de Paris

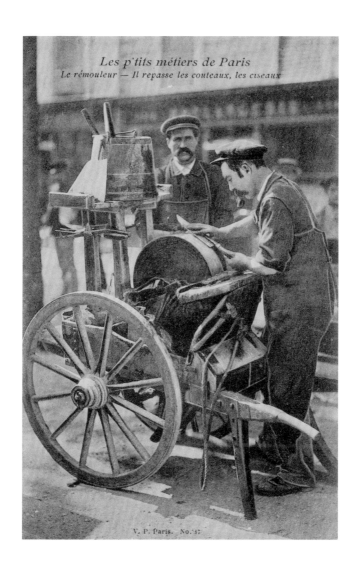

Les p'tits métiers de Paris
Le rémouleur — Il repasse les couteaux, les ciseaux

V. P. Paris. No. 47

..

47 | *The knife grinder — He sharpens knives and scissors*

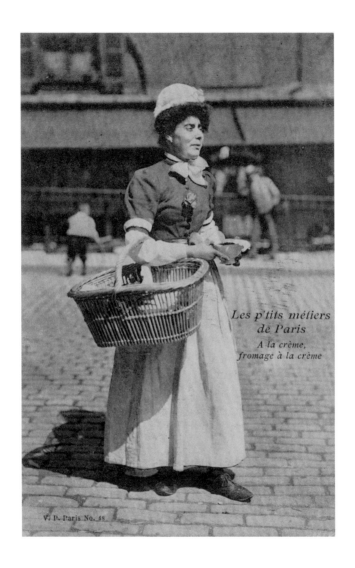

Les p'tits métiers
de Paris
A la crème,
fromage à la crème

V. P. Paris No. 48

. .

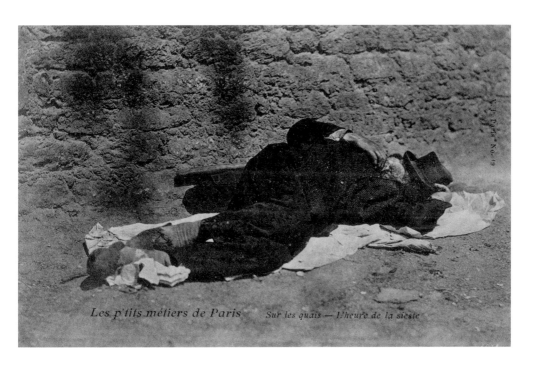

Les p'tits métiers de Paris Sur les quais — L'heure de la sieste

49 | *Along the quays — Nap time*

A number of the scenes in Atget's petits métiers do not depict trades at all
but are simply observations of life in the street.

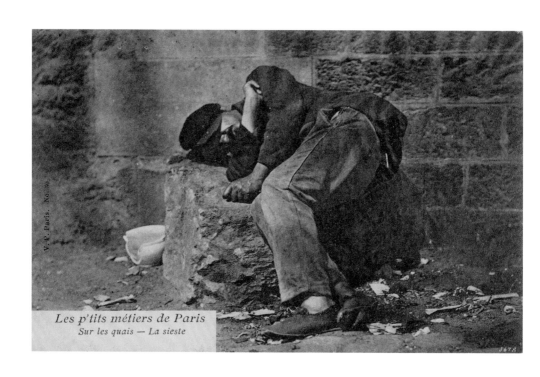

Les p'tits métiers de Paris
Sur les quais — La sieste

50 | *Along the quays — Nap time*

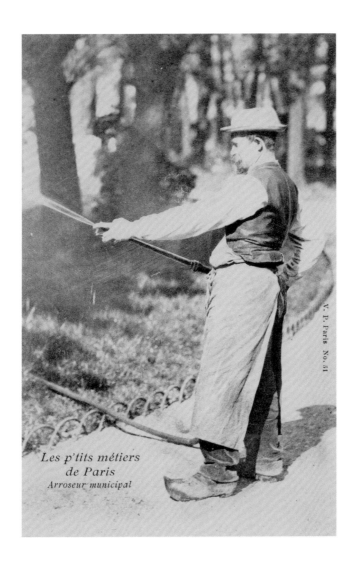

Les p'tits métiers
de Paris
Arroseur municipal

V. P. Paris No. 51

| *Municipal gardener*

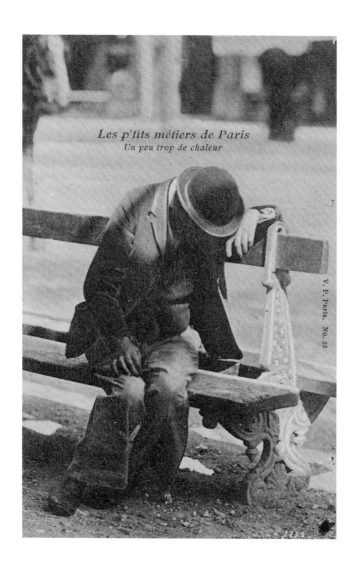

Les p'tits métiers de Paris
Un peu trop de chaleur

V. P. Paris. No. 52

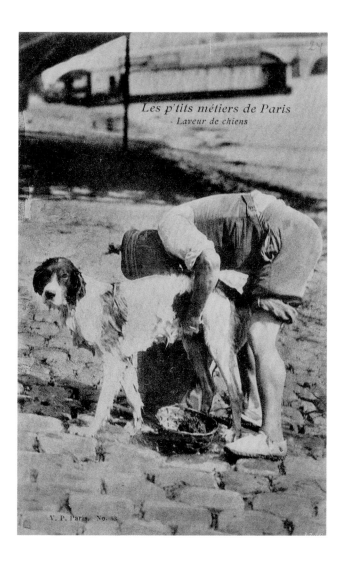

Les p'tits métiers de Paris
· Laveur de chiens

V. P. Paris. No. 53

..

53 | *Dog washer*

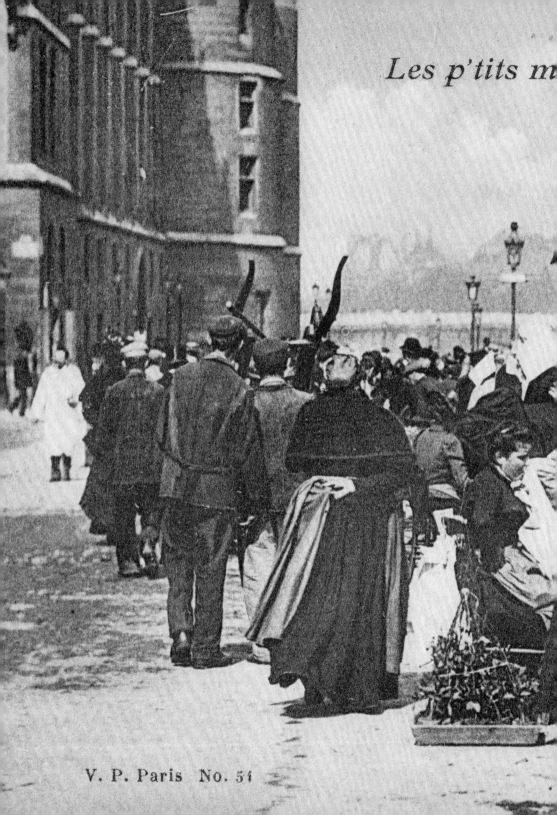

Les p'tits m

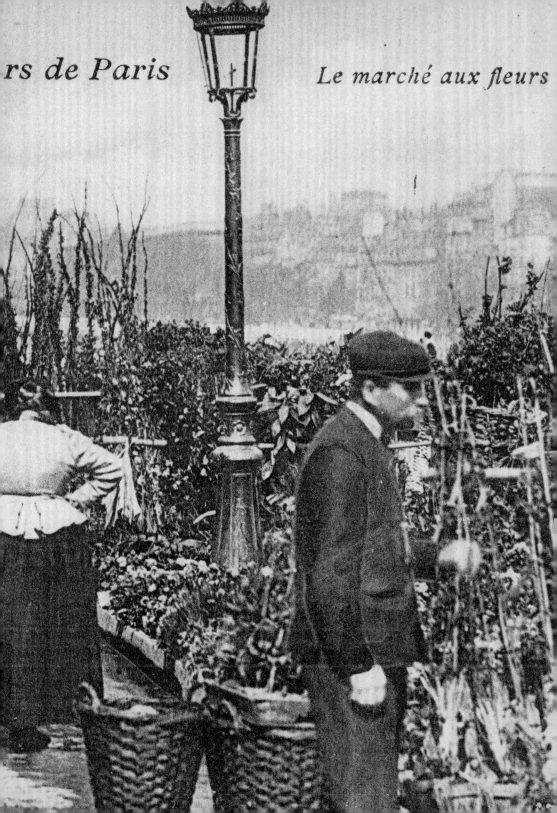

rs de Paris Le marché aux fleurs

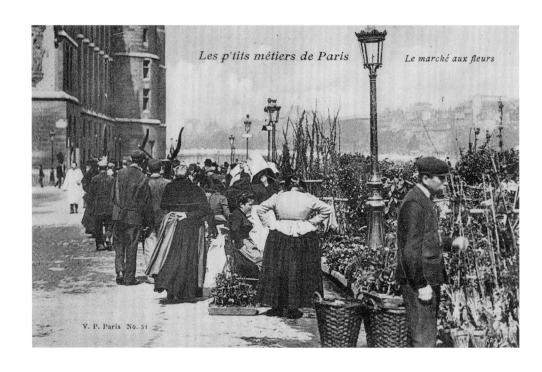

Les p'tits métiers de Paris Le marché aux fleurs

V. P. Paris No. 51

....................................

54 | *The flower market*

This is the flower market at the Quai de l'Horloge,
along the north side of the Île de la Cité.

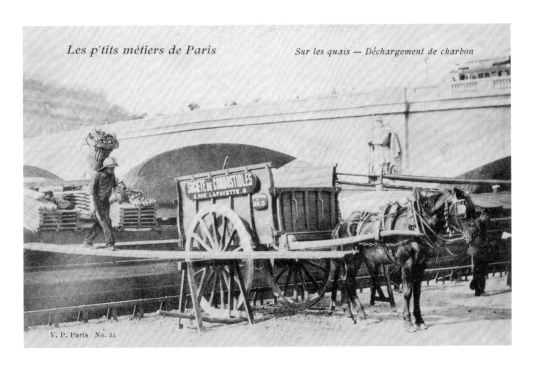

Les p'tits métiers de Paris *Sur les quais — Déchargement de charbon*

V. P. Paris No. 55

..

55 | *Along the quays — Unloading charcoal*

Around 1900, charcoal was still a major
heat source in older buildings.

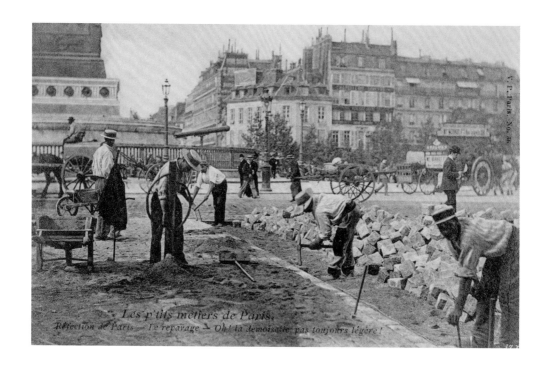

Les p'tits métiers de Paris.
Réfection de Paris — Le repavage — Oh! la demoiselle pas toujours légère!

56 | *Repairing Paris — Repaving — Oh, that girl ain't light!*

The last part of this caption seems to capture an overheard phrase,
perhaps as a worker tried to lift a particularly heavy cobble
in the shadow of the July Column, in Place de la Bastille.

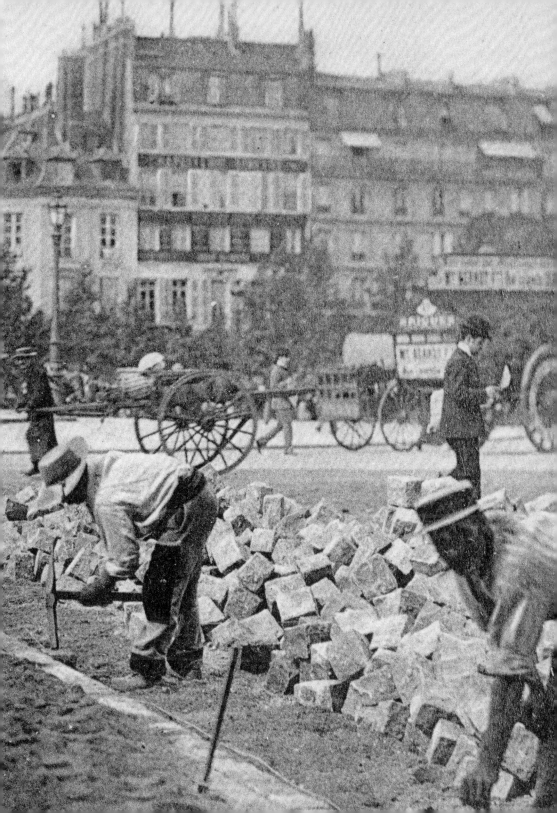

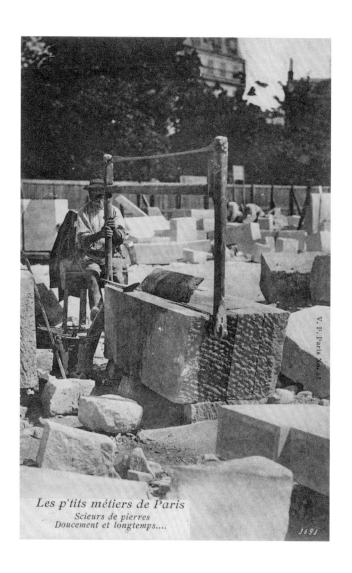

Les p'tits métiers de Paris
Scieurs de pierres
Doucement et longtemps....

V. P. Paris No. 57

1693

..

57 | *Cutting stones. Gently and slowly . . .*

Despite paving stones' weight, cutting them requires
great delicacy and care, lest they crack or break.

Les p'tits métiers
de Paris
Le Biffin

V. P. Paris No. 58

58 | *The rag-and-bone man*

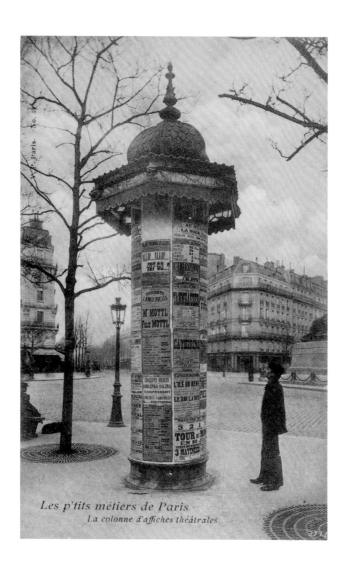

Les p'tits métiers de Paris
La colonne d'affiches théâtrales

59 | *A column with theatrical posters*

Advertising columns, such as this one in Place Denfert-Rochereau,
became one of the symbols of the bright, new, modern Paris.

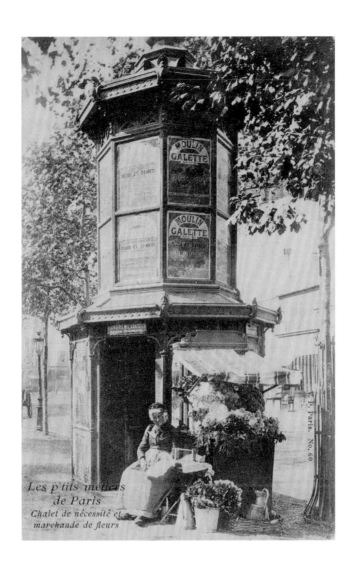

Les p'tits métiers
de Paris
Chalet de nécessité et
marchande de fleurs

..

60 | *Public toilet and flower seller*

The French phrase *chalet de nécessité* suggests
a very genteel sort of public toilet.

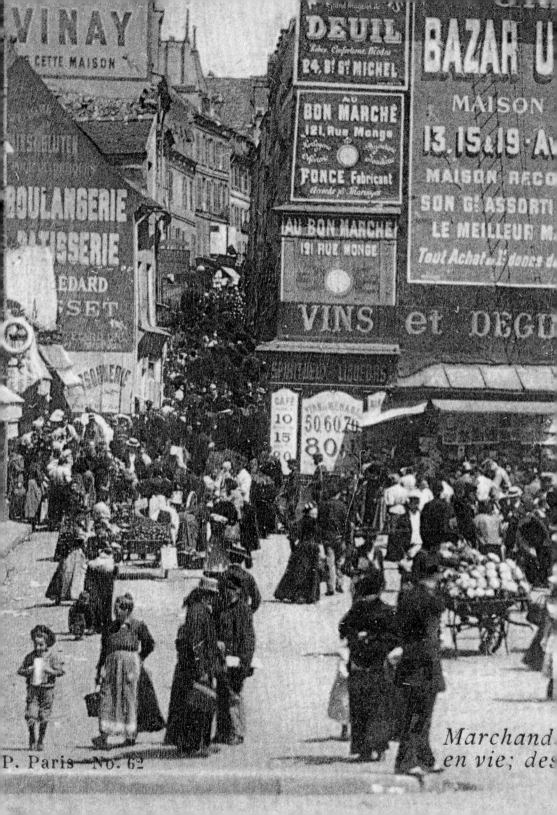

P. Paris — No. 62

Marchand
en vie; des

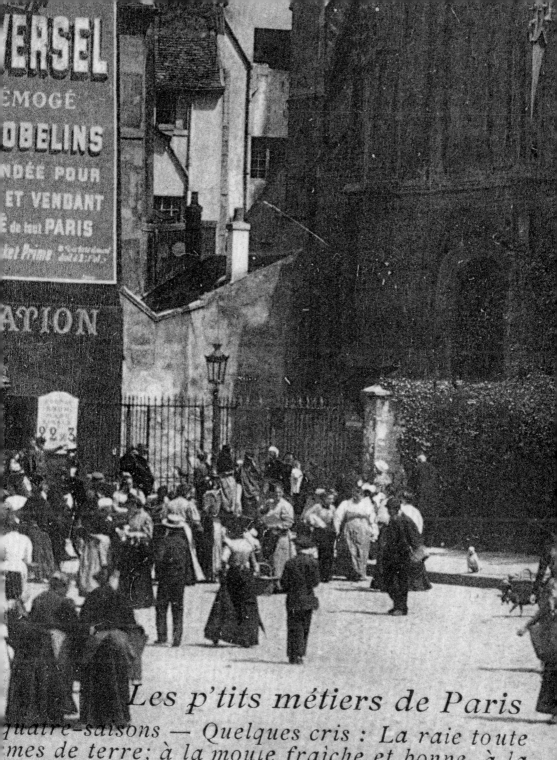

Les p'tits métiers de Paris

quatre-saisons — Quelques cris : La raie toute
mes de terre ; à la moule fraîche et bonne, à la
moule...

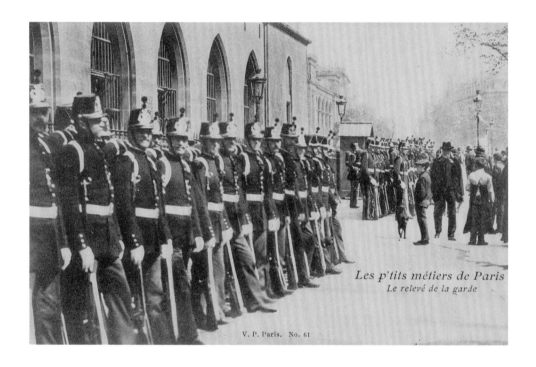

Les p'tits métiers de Paris
Le relevé de la garde

V. P. Paris. No. 61

..

61 | *Changing of the guard*

Atget shows the ceremonial change of guards at the Conciergerie,
the medieval palace on the Île de la Cité that later served as a prison.

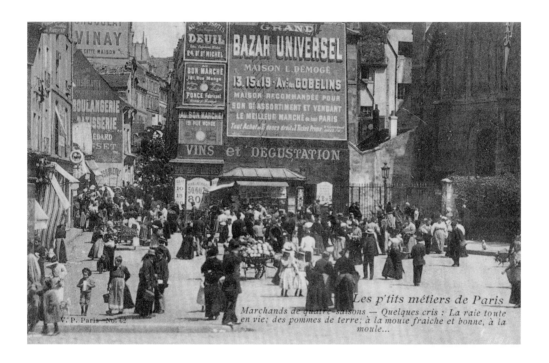

Les p'tits métiers de Paris
Marchands de quatre-saisons — Quelques cris : La raie toute
en vie; des pommes de terre; à la moule fraîche et bonne, à la
moule...

V. P. Paris—No. 62

..

62 | *Street vendors — Some cries: Skate, live skate; potatoes;*
good, fresh mussels, mussels . . .

This is Place Saint Médard, whose tangle of old buildings
Atget photographed several times. Most of the buildings survive,
but the riot of signage and street vendors is gone.

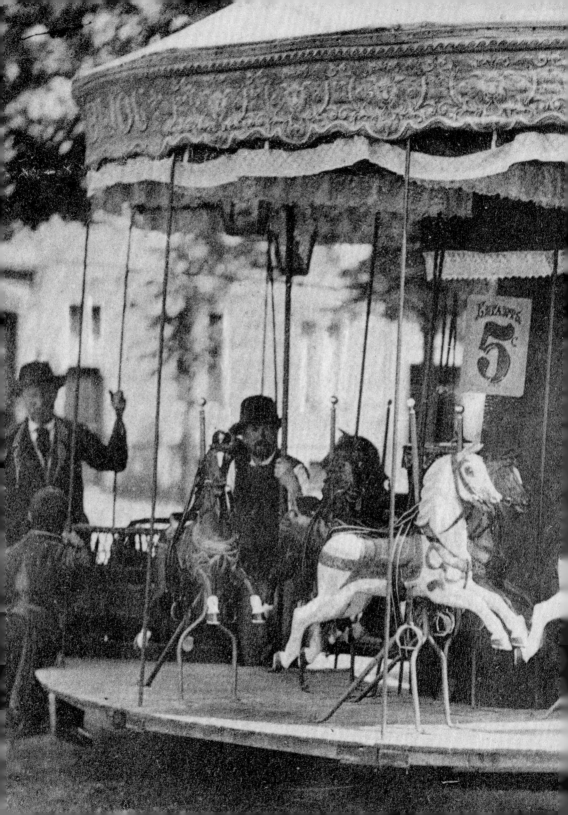

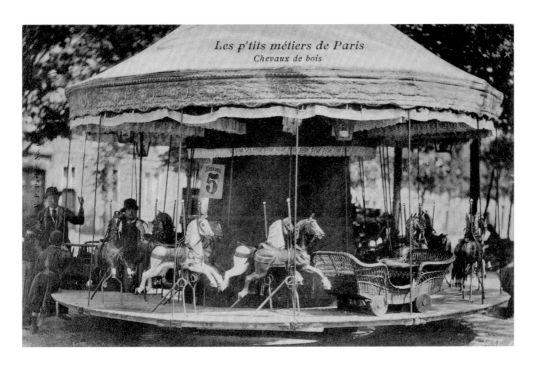

Les p'tits métiers de Paris
Chevaux de bois

63 | *Wooden horses*

This carousel graced the Fête foraine des Invalides fairgrounds.

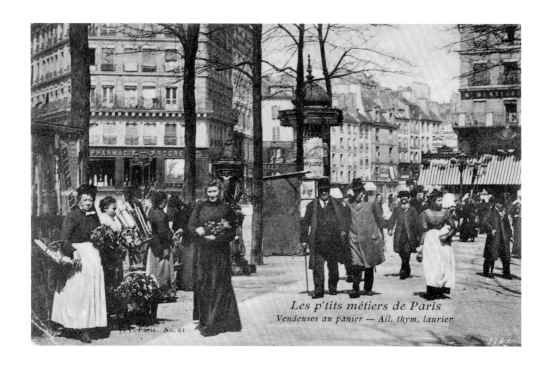

Les p'tits métiers de Paris
Vendeuses au panier — Ail, thym, laurier

64 | *Street sellers. Garlic, thyme, laurel*

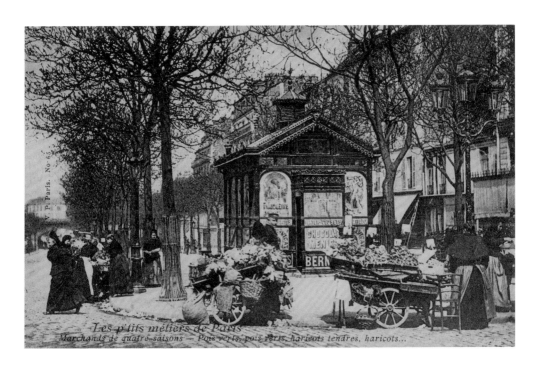

Les p'tits métiers de Paris
Marchands de quatre-saisons — Pois verts, pois verts, haricots tendres, haricots...

65 | *Street vendors: Green peas, green peas, tender beans, beans . . .*

Parisian street vendors were (and sometimes still are) called
vendors *de quatre saisons* — "of the four seasons" — to suggest that
the produce they sell is fresh and in season.

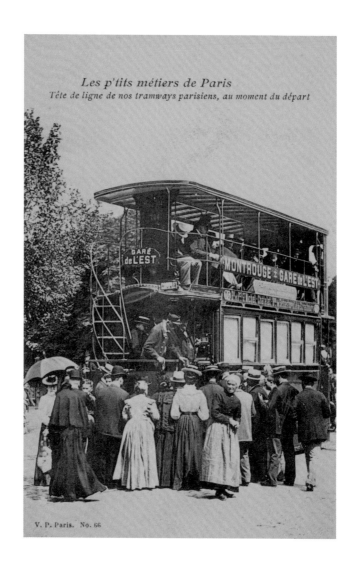

Les p'tits métiers de Paris

Tête de ligne de nos tramways parisiens, au moment du départ

V. P. Paris. No. 66

................................

66 | *Beginning of the line for our Parisian tramways, at the moment of departure*

This shows the southern terminus of the Montrouge–Gare de l'Est tramway,
which ran through many of the neighborhoods Atget captured in these postcards.

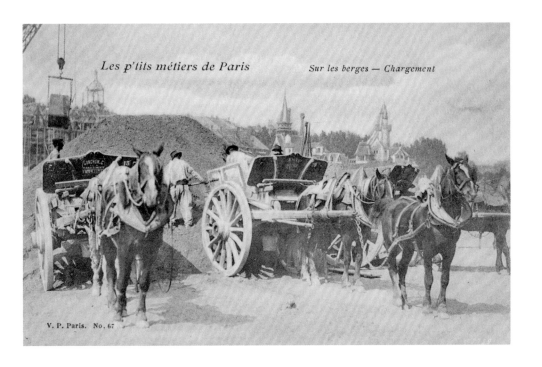

Les p'tits métiers de Paris *Sur les berges — Chargement*

V. P. Paris. No. 67

67 | *On the riverbank—Loading*

Atget took this photograph during construction for
the Exposition Universelle of 1900. The fair's theme park of Old Paris,
along the banks of the Seine, can be seen in the background.

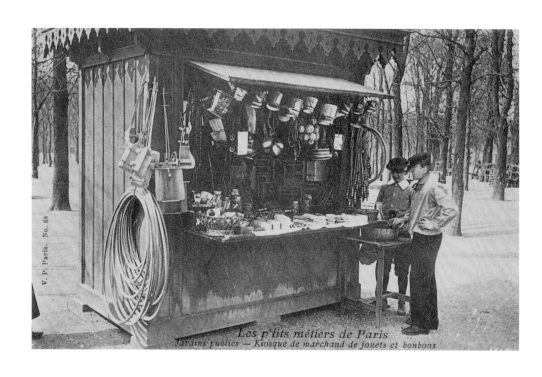

Les p'tits métiers de Paris
Jardins publics — Kiosque de marchand de jouets et bonbons

68 | *Public parks — Kiosk for a seller of toys and candies*

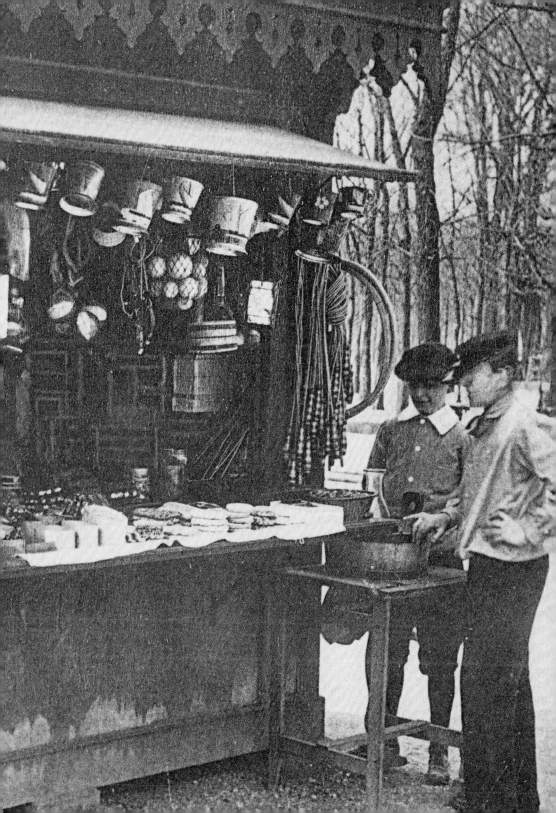

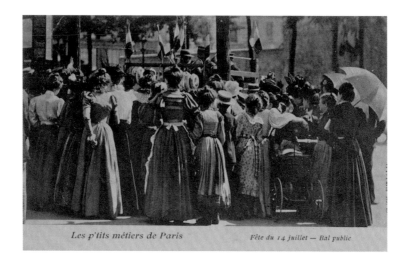

Les p'tits métiers de Paris Fête du 14 juillet — Bal public

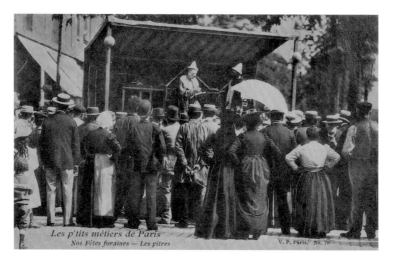

Les p'tits métiers de Paris
Nos Fêtes foraines — Les pitres V. P. Paris. No. 76

69 | *Bastille Day — Public dance*

70 | *Our fairgrounds — The clowns*

All of Atget's postcards of fairgrounds seem to show the Invalides funfair,
which spread out along the very formal gardens between Les Invalides and the Seine.

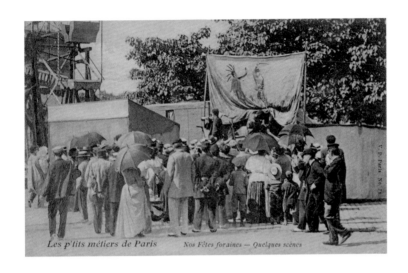

Les p'tits métiers de Paris Nos Fêtes foraines — Quelques scènes

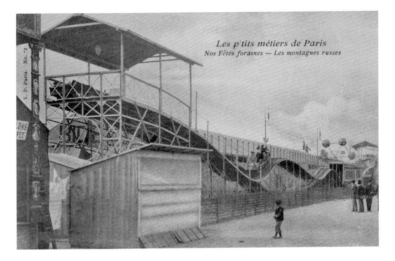

Les p'tits métiers de Paris
Nos Fêtes foraines — Les montagnes russes

....................................

71 | *Our fairgrounds — Some scenes*

72 | *Our fairgrounds — The roller coaster*

Even today, roller coasters in France are called *les montagnes russes*,
or "Russian mountains."

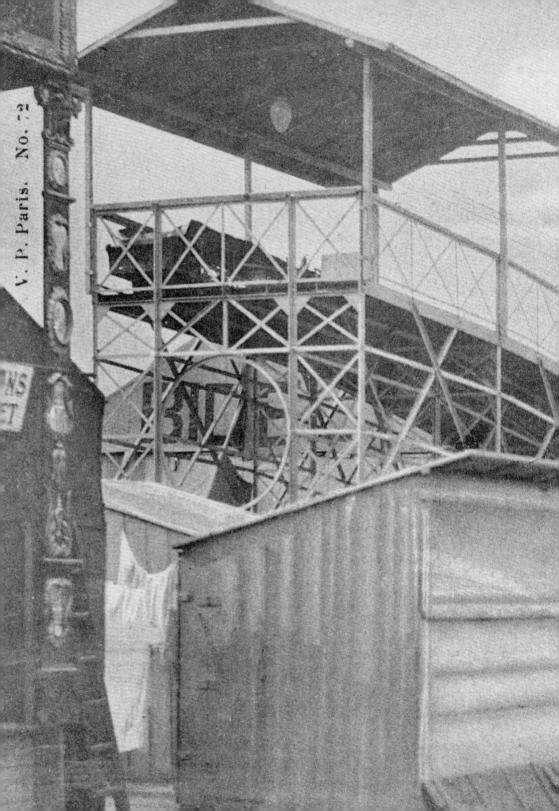

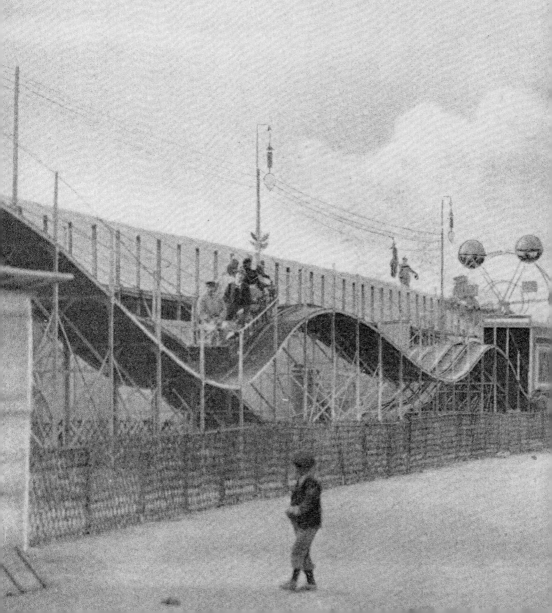

Les p'tits métiers de Paris
Nos Fêtes foraines — Les montagnes russes

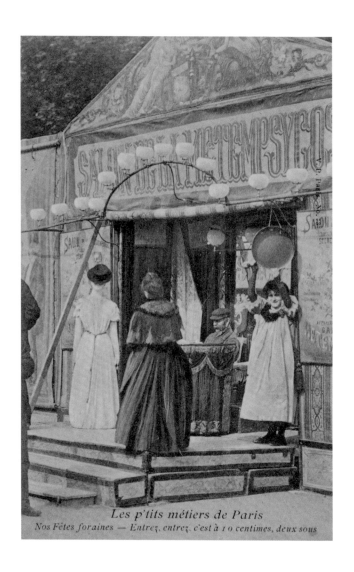

Les p'tits métiers de Paris

Nos Fêtes foraines — Entrez, entrez, c'est à 10 centimes, deux sous

| *Our fairgrounds — Step right up, step right up. Ten centimes, two sous*

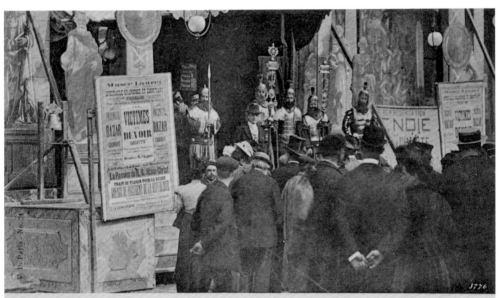

Les p'tits métiers de Paris Nos Fêtes foraines — L'heure de la parade

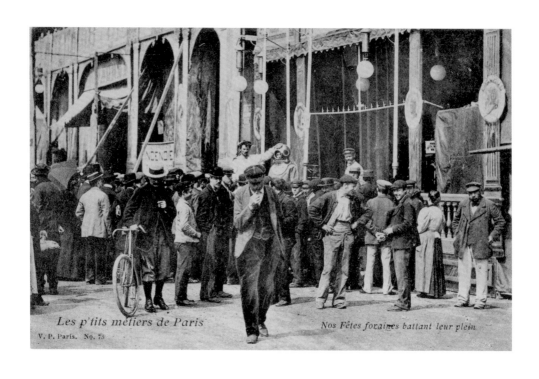

Les p'tits métiers de Paris

V. P. Paris. No. 75

Nos Fêtes foraines battant leur plein

75 | *Our fairgrounds in full swing*

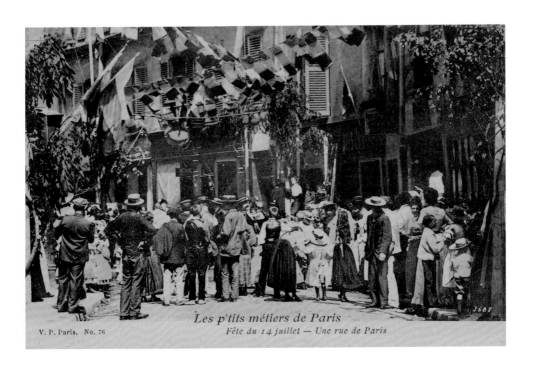

Les p'tits métiers de Paris

Fête du 14 juillet — Une rue de Paris

V. P. Paris. No. 76

76 | *Bastille Day — A Parisian street*

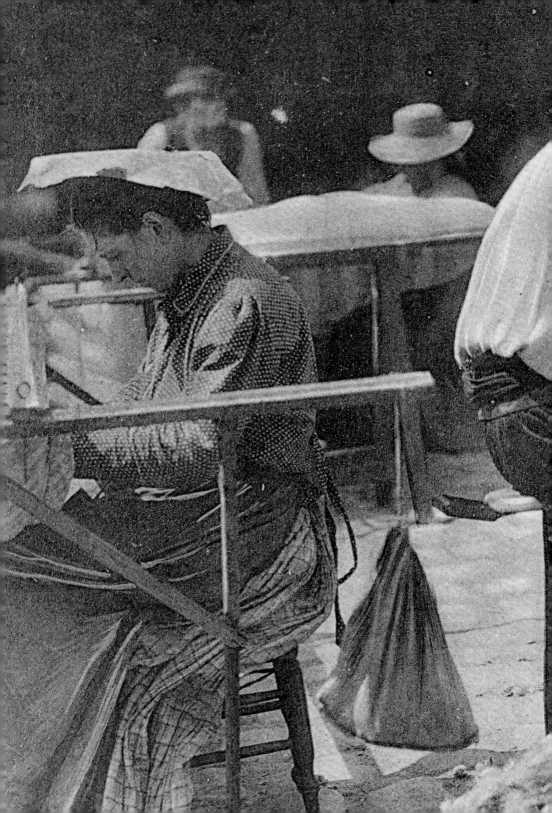

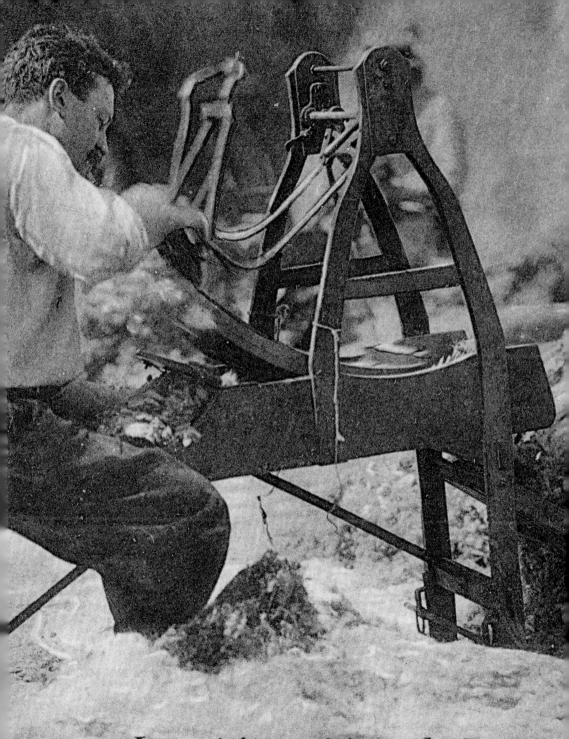

Les p'tits métiers de Paris
Cardeurs de matelas

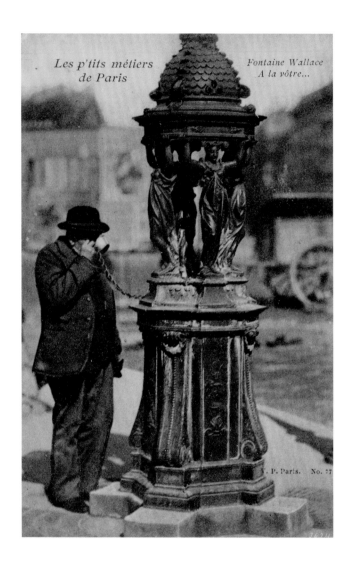

Les p'tits métiers
de Paris

Fontaine Wallace
A la vôtre...

V. P. Paris. No. 77

..

77 | *Wallace Fountain. To your health . . .*

Wallace Fountains were a network of public drinking fountains paid for by the Englishman
Richard Wallace, a resident of Paris and the founder of London's eponymous
Wallace Collection, famous for its holdings of eighteenth-century French painting.

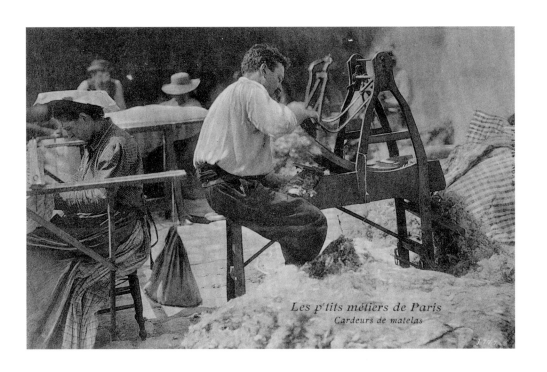

Les p'tits métiers de Paris
Cardeurs de matelas

78 | *Mattress stuffers*

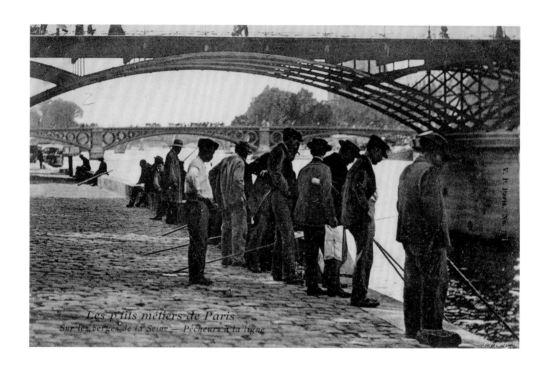

Les p'tits métiers de Paris
Sur les berges de la Seine — Pêcheurs à la ligne

79 | *On the banks of the Seine — Fishermen on the line*

Hopeful anglers troll the Seine in central Paris, just upstream
from the Pont des Arts and the Pont du Carrousel.

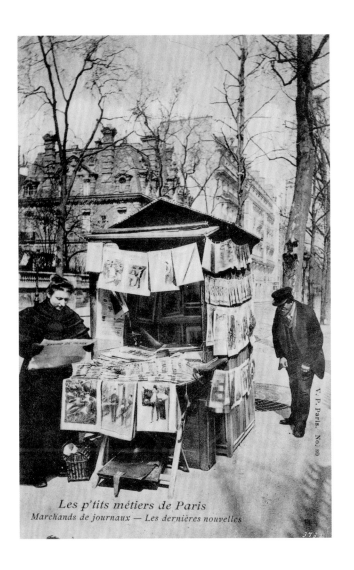

Les p'tits métiers de Paris
Marchands de journaux — Les dernières nouvelles

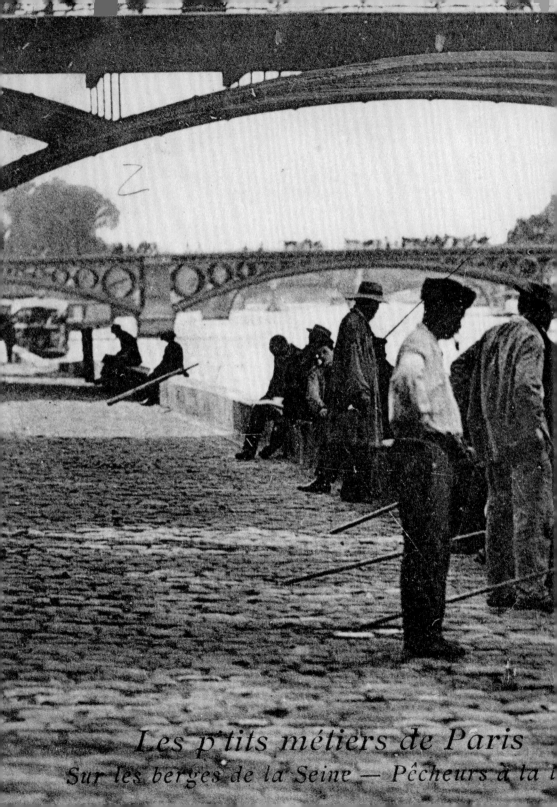

Les p'tits métiers de Paris
Sur les berges de la Seine — Pêcheurs à la l...

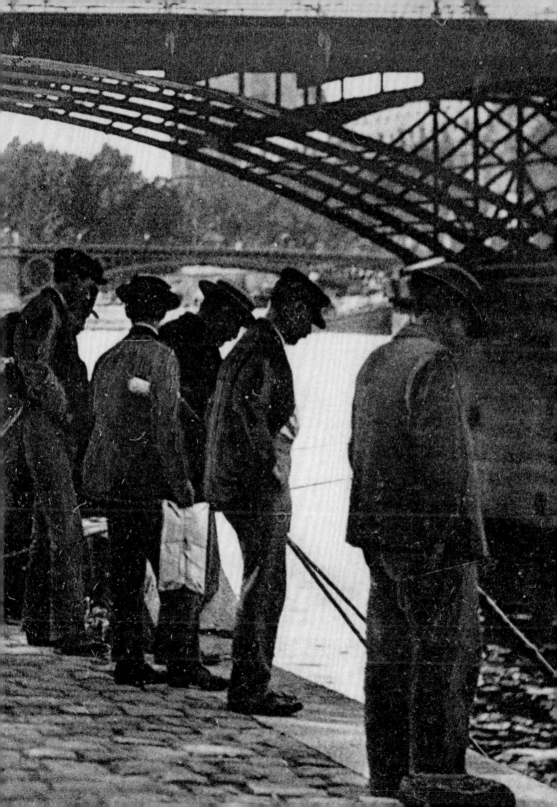

List of Illustrations

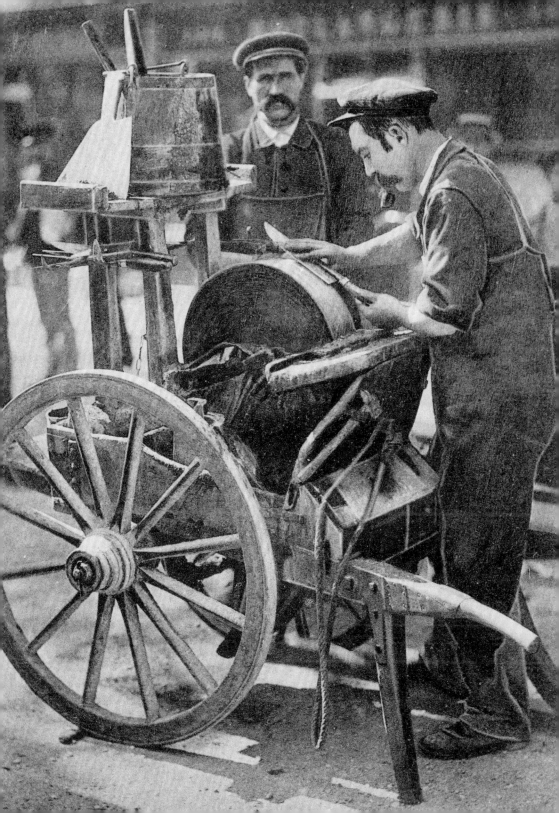

MFA Publications
Museum of Fine Arts, Boston
465 Huntington Avenue
Boston, Massachusetts 02115
www.mfa.org/publications

Funds for this publication provided by the
American Art Foundation, Leonard A. Lauder,
President.

ISBN 978-0-87846-844-7
Library of Congress Control Number: 2017934269

While the objects in this publication necessarily
represent only a small portion of the MFA's
holdings, the Museum is proud to be a leader within
the American museum community in sharing the
objects in its collection via its website. Currently,
information about approximately 400,000 objects is
available to the public worldwide. To learn more
about the MFA's collections, including provenance,
publication, and exhibition history, kindly visit
www.mfa.org/collections.

For a complete listing of MFA publications,
please contact the publisher at the above address,
or call 617 369 3438.

COVER:
Details of no. 80 (front) and no. 56 (back) from the
postcard series *The Little Trades of Paris*, about 1904

DETAILS:
p. 1: no. 64; pp. 2–3: no. 9; p. 4: no. 59; pp. 18–19:
no. 26; p. 20: no. 41; p. 127: no. 47

All illustrations in this book were photographed
by the Imaging Studios, Museum of Fine Arts,
Boston, except where otherwise noted.

Edited by Anna Barnet
Editorial assistance by Anne Levine
Copyedited by Dalia Geffen
Designed by Susan Marsh
Typeset by Matt Mayerchak in Fournier,
with Corvinus Light and Linoscript display
Production by Terry McAweeney
Printed on 150 gsm Tatami white
Printed and bound at Graphicom, Verona, Italy

Distributed in the United States of America
and Canada by
ARTBOOK | D.A.P.
75 Broad Street, Suite 360
New York, New York 10004
www.artbook.com

Distributed outside the United States of America
and Canada by
Thames & Hudson, Ltd.
181A High Holborn
London WC1V 7QX
www.thamesandhudson.com

FIRST EDITION

Printed and bound in Italy
This book was printed on acid-free paper.